ÆSTHETIC QUALITY
A Contextualistic Theory of Beauty

Aesthetic Quality

A Contextualistic Theory of Beauty

By

STEPHEN C. PEPPER

Professor of Philosophy, University of California

GREENWOOD PRESS, PUBLISHERS
WESTPORT, CONNECTICUT

Copyright 1937 by Charles Scribner's Sons, New York

Copyright 1965 by Stephen C. Pepper

Reprinted with the permission of Stephen C. Pepper

Reprinted in 1970 by Greenwood Press, a division of Congressional
Information Service, 88 Post Road West, Westport, Connecticut 06881

Library of Congress catalog card number 79-110052

ISBN 0-8371-4437-X

Printed in the United States of America

10 9 8 7 6 5 4 3 2

TO

THE MEMORY OF

SHERMAN HOAR PEPPER

PREFACE

In part, this book is written in order to present certain observations about the nature of æsthetic experience and the manner in which such experience is organized. But in part also, it is an effort to present a somewhat new theory of æsthetics in a more single-minded and consistent way than has hitherto been done. These two aims intertwine, since no theory can be adequately explained without the observations that support it, and no mere list of observations is of much value without a theory to order them. Moreover, it is my conviction, for which I hope some day to offer the necessary evidence, that good criticism in art is based on good æsthetic theory (even though held unconsciously) and only on good theory, so that there is great practical importance in getting æsthetic theory clear. This practical aim is never entirely out of my mind in the following attempt to clarify the implications for æsthetics of the pragmatic or contextualistic movement.

PREFACE

Since this book is an attempt to isolate the results of a recent movement in æsthetics, its materials have been gathered from many sources, and there is much indebtedness to contemporary or nearly contemporary writers. Chief among these are Croce, Bergson, and William James, who seem to have had the initial insights, and then Collingwood, Carritt, I. A. Richards, Helen Parkhurst, Ducasse, Leo Stein, Max Eastman, Parker, Prall, Whitehead, and Dewey, who have either had similar insights of their own or in one way or another have deepened and enriched those of the earlier men.

These writers do not in themselves constitute a movement, and, if some of them read this list, they may think themselves in strange company. But they have been named because they are writers from whom I have drawn material and for whom, I need not add, I have great respect. I do not know how safe it is for me to thank them, since some of them may not approve of what I have done with my quarryings from their works, nor even recognize the material as their own in the environment in which I have placed it. It is even possible that sometimes I have been

mistaken in the material, and have seen in it properties I was not supposed to see. If so, my sense of gratitude should perhaps be even greater. But if there is any value in this book, I should be honored to have these writers accept as much of its thought for their own as they are willing to acknowledge.

I wish particularly to thank Helen Parkhurst, Prall, Ducasse, and Parker for going over the manuscript at an advanced stage, and making suggestions to the great improvement of the book; also my colleagues and friends, who have seen or heard parts of the manuscript or at least discussed some of its ideas; and also Ralph Barton Perry, whose influence, as my first thorough teacher in Philosophy and as a frequent source of criticism and encouragement in succeeding years, is more permeatingly present in these pages than perhaps even he suspects.

<div style="text-align: right">S. C. P.</div>

CONTENTS

ÆSTHETIC QUALITY

INTRODUCTION

THE full justification of an æsthetic theory extends far beyond the bounds of the æsthetic field. For it depends not only on a description of facts, but on an interpretation determining what are the facts. It depends, in a word, on a philosophy. Such a full justification every æsthetic theory should have, and, I believe, the theory which I am about to explain does have. But I am going to ask the reader to look elsewhere for it.

I say this at once, because I do not wish to seem to be doing something that I am not. I do not wish it to be thought that the interpretation of æsthetic fact, which I shall present, is the only interpretation which a man of intelligence and good taste could accept; or that if a man does not accept this interpretation as ultimate, his intelligence and good taste are open to doubt. Nor do I wish it to be thought that because it is possible to offer a rather complete and illuminating theory of beauty on the basis of this

3

interpretation, thereby this interpretation is proved *the* true æsthetic theory.

My belief is that there are a number, though a limited number, of well justified ways of approaching the field of æsthetics. These amount to different hypotheses regarding the nature of that field. Each hypothesis illuminates the field in a somewhat different way, and brings out features the others do not. Each hypothesis has its corners of obscurity. The hypothesis to be presented here is just one of these. Its particular modern interest is that it is the newest of them all, having its basis in the youngest of philosophies, pragmatism, or, as I prefer to call it, contextualism.

To the suggestion, Why not combine all the valuable hypotheses into one which has the good points of each? the answer is that the resulting confusion more than neutralizes the advantages hoped for. It is better to develop each hypothesis separately. We can then see clearly just what each amounts to. Furthermore, we gain the objectivity of a consistent point of view and are able to extend it for ourselves as far as it will go.

With the eclectic method, however, the ar-

bitrary choice of the writer intervenes, taking
one feature here, and another there, so that a
reader never knows what will be taken next or
why, nor is there any way of checking on the
choices. Sometimes the choices have no justifi-
cation whatever, and cannot be regarded as
æsthetic facts on any interpretation.

A good example of the eclectic method is
I. A. Richards' *Principles of Literary Criti-
cism*. It is especially good, because Richards
exhibits unusual intelligence in the features he
selects from different æsthetic theories. Even
in this book, however, one never knows which
way the next chapter, or even the next para-
graph, is going to jump. The book is a jumble
of mechanistic, idealistic, and contextualistic
interpretations. Like a book of proverbs, it is
full of wisdom; but, also, like a book of proverbs,
it is full of half truths, and consequently half
falsehoods, and of implicit and even explicit
contradictions. It lacks, therefore, in an eminent
degree what Richards of all æstheticians most
desires of an æsthetics—objectivity.

One is better informed by reading separate
books that carry out consistent interpretations.

All the mechanistic features which Richards arbitrarily selects, can be found implicitly if not explicitly in Santayana's *The Sense of Beauty,* and the idealistic features in Bosanquet's *Three Lectures on Æsthetics.* There has not appeared, I think, a contextualistic book as consistently worked out in its way as those just mentioned are in theirs, but Dewey's *Art as Experience* comes very near being such a book. A careful reading of these three books gives a man a sounder and steadier conception of the æsthetic field than a reading of such a book as Richards'. These three books can be read with any degree of care and scrutiny, and inconsistencies found in them can be straightened out in the manner of the books. The more carefully one reads them and reflects upon them the further one is carried by a sort of internal momentum into the universe of facts with which they deal. This cannot be said of Richards' book. On first reading, it is persuasive and reminiscent, but the more carefully one reads it the more one is balked, annoyed, and confused. The field which the book was supposed to explain and clarify grows more and more befogged

—grows so *unless* one begins to segregate the arbitrary selections and to notice that this particular group of facts is the sort that a Santayana develops, and this the sort a Bosanquet develops, and this the sort a Dewey develops. But if, in order to understand an eclectic book, we have to go in the end to the straightforward, single-minded books, what is the advantage of the eclectic book?

So, I shall try here to keep within a single interpretation—the contextualistic interpretation. And far from following the practice of the past, in nearly all such writing, of setting up the point of view of the author as final and ultimate, I plead for the opposite attitude. The contextualistic point of view is only one of several equally good points of view. It should be sympathetically considered, but it should immediately be compared with other equally justifiable points of view such as the mechanistic and the idealistic.

There will, accordingly, be practically no polemical material in this book, such as fill the pages of many writings on æsthetics. For a common procedure is to begin by exhibiting the

shortcomings of outstanding æsthetic theories of the day. This *can* be done in all fairness, for there is no hypothesis that does not have its Achilles' heel. But the implication of this procedure is that the criticisms have disposed of all rival theories, and that consequently the field is clear for the new theory which can now have the field all to itself. The method is very effective, and entirely unsound. The new theory is often not as good as the ones 'disposed' of. But more than that, unless the new theory is absolutely faultless, or at least very much better than those criticized, the criticized theories will still be needed to exhibit features which the new theory probably obscures. I have no desire to make the contextualistic theory appear to conquer all others. On the contrary, I desire that it should not seem to do so, for a submergence of the other good theories would be very unhealthy both in theory and in criticism.

There is another mode of polemic that is even less excusable than the foregoing. I refer to the method of quoting some author of an alien theory, showing that his description of the facts under discussion is not the same as the descrip-

tion of the facts consistent with the point of view of the author writing, and then concluding, sometimes with accompanying sarcasm, that the alien author's description was in error. The alien description might, of course, be in error, but not because of the discrepancy with the description in the writer's book. If both theories happen to be about equally good, so far as can be told, then both descriptions are sorely needed to compensate for each other's possible omissions, or distortions.

If from lack of reference to alien theories, the succeeding pages sometimes seem dogmatic, the reader is asked to accept the foregoing paragraphs as a general proviso placed over the whole book. I shall assume the contextualistic point of view, and shall proceed to a description of facts directly in those terms, and shall count it a slip if I am caught outside that point of view. That is the only clear and objective way of writing an æsthetics, I believe. But I do not believe that the contextualistic point of view is the only justifiable or profitable point of view.

Are we to assume, then, that there are no stubborn facts of æsthetics? Cannot an æsthet-

ics be scientifically developed through experiments and inductions from undoubted facts that do not depend upon any point of view? There are not many facts that do not depend upon a point of view. What is a chair to us, is something quite different to a dog. And when we try to "reduce" the chair to facts that would be identical both for us and the dog, there is not much left of the chair. Physics has persistently sought such invariant facts, and the result has been to strip the world of most of its character and to offer us instead pointer readings. Even these are not quite free from a point of view, for a man must be educated to read a scale and tell off numbers. If the ideal of a fact is a physical fact, there are not many such facts relevant to æsthetics. And if by objectivity is meant only what every normal man, who knows how to count and can distinguish black from white, would agree to, then æsthetics has not that sort of objectivity.

But there is another sort of objectivity that æsthetics does have, and it lies at the opposite pole from scientific objectivity. For scientific objectivity consists in that which all normal men

can agree upon with the minimum of education, whereas æsthetic objectivity consists in that which all normal men can agree upon with *sufficient* education. The one is an objectivity of disintegration, the other an objectivity of integration. So science seeks to control its results by a maximum elimination of outlying effects, while fine art seeks to control its results by a maximum encompassing of outlying effects. Fine art conscripts elements to function in the mutual determination of one another, having no faith in the self-determination of an element. For there is nothing in art so variable as an isolated element such as a single visual line, a single color, a single word. But place any one of these in a skilfully framed context and its character becomes as specific as anything in the world.

This is the reason that the psychological laboratory has furnished such scanty material to the understanding of art. For the psychological laboratory is modeled on the physical laboratory, and its ideal of objectivity is the physical ideal of control by isolation and disintegrative analysis. The psychologist has persistently tried

to get æsthetic results by lifting lines, colors, sounds, rhythms, words out of all contexts, and even out of all cultural education. His conception of a clean experiment is a Mowgli in a dark room conditioned to 'yes,' and 'no,' and 'very yes,' and 'very no,' and responding in this manner to octaves and minor thirds, colors and color combinations, and rectangles of various proportions. I do not mean to imply that interesting and relevant results cannot be obtained for æsthetics in this manner. They can be and they have been. But these results apply to the outskirts and not to the heart of the subject. The method is essentially just wrong. The great artist himself is the laboratory experimenter in æsthetics, and it is the abundance of this material at hand and not the reverse that embarrasses us. The problem for the empirical æsthetician is not to get the work of art out of its cultural setting, and each element in the work out of its context. That method is so to treat the matter under observation that the treatment destroys the facts to be observed. The problem for the empirical æsthetician is just the opposite, that of exhibiting the relevant cultural setting of the work

of art and the relevant context of each discriminated detail. Thereby a genuine objectivity is obtained. A person of adequate culture who could not recognize the beauty of "The Eve of St. Agnes," we should consider just as abnormal as a person who always thought that green was gray.

A few words, now, about the problem of locating the field of æsthetics. One way of beginning a book on æsthetics is to remark that everybody knows well enough what beauty and ugliness are for the purposes of general location, and then without more ado commence to analyze these concepts in the particular manner of the book. When all is said and done, this is not a bad way. It amounts to starting with the common-sense notion of the subject, and I am not acquainted with any safer notion to start with.

But it is always possible that a common-sense notion has become so obscured and involved as to mean several quite different things or even to mean nothing at all. There are certainly several common uses of the term beauty, that have nothing to do with æsthetics. "That is beautiful," often means no more than "That is fine,"

a general term of commendation for anything whatever. On the other hand, the term may be as restricted as in the shop sign "Beauty Parlor." Common sense itself recognizes several uses of the term, spreading either side of specifically æsthetic beauty.

My belief is that the norm of æsthetic beauty for common sense is a character or set of characters associated with what are known as the classics in art. The classics—works of Homer, Dante, Shakespeare, Milton, Molière, etc.—are patently a more or less definite group of objects recognized as having an important bearing on æsthetic matters. When a writer like Tolstoy tosses them aside, and tells us that the æsthetic field is something quite different and that the works of these men are not æsthetic objects, we are at first astonished and then convinced that it is Tolstoy and not the common man who is misusing the term. Tolstoy may be right or wrong in his estimate of the value of traditional writings on æsthetics. But without a reputable exception other than Tolstoy, so far as I know, all writers on æsthetics from Plato and Aristotle down deal respectfully with the classics. The

classics furnish, it seems to me, the safest well recognized group of facts for roughly locating in a preliminary way the field of our inquiry.

To say, however, that the facts which we are studying are the sort of facts of which classic works of art afford outstanding examples, is not to beg the question in æsthetics, is not to determine antecedently the results of our enquiry in any more definite way than facts ought to determine the results. It is not to say that every so-called masterpiece is an object of high æsthetic value, nor that objects not called masterpieces are not of equally high or higher æsthetic value, nor that some so-called masterpieces may not have a negative æsthetic value or even no æsthetic value. It does not even determine an objectivity of æsthetic values. It determines nothing at all beyond a rough preliminary demarcation of the field within which æsthetic enquiry is to begin. But it is important to have such a preliminary demarcation in mind in order to know that what we are talking about under the term æsthetic, is the subject most other informed men are talking about under the same term.

There is a good deal of confusion today in æsthetic terminology. I shall use the term, æsthetic, to cover the whole field of æsthetic values. Beauty, I shall use as the term for positive æsthetic value, and ugliness for negative æsthetic value. Sometimes I may slip into the use of beauty as equivalent to the whole æsthetic field. That is a frequent usage in æsthetic writings, and is particularly excusable in the theory I am about to explain, because in this theory it is questionable if there is any ugliness, any negative æsthetic value. It seems probable that if an object is not beautiful, it is not æsthetic at all, and that, if a negative value attaches to it, the value is derived from some other than æsthetic source; it is a negative moral or practical value of some kind. But we shall go into this matter later.

'Beautiful' is sometimes used in a special, laudatory sense in æsthetic writings to signify that the object is not only one of positive æsthetic value but of great positive value. This is a quantitative sense of the term as distinguished from the broader sense which is qualitative or definitive. The taste of an orange, or its shape

and color, might be beautiful in the broad definitive sense of the term, but only such things as mountains, and sunsets, and exquisite flowers, and poems, pictures, and music, seem to deserve the term in the narrower, eulogistic sense. It is often convenient to be able to use the term in either sense, and the double use is rarely confusing. The broader use may be called qualitative or definitive beauty, the narrower quantitative or standard beauty.

The relation between the two is important, and can be very simply stated. Definitive beauty is the field of æsthetic value, as this comes to be defined with precision. If among the definitive characters of the field, some are capable of quantification (that is, have degrees of intensity, or degrees of extent, or the like), these quantities constitute relevant quantitative standards in the field. And these quantitative standards determine standard beauty. Standard beauty, in short, is a great quantity of definitive beauty. Any instance of standard beauty is, consequently, an instance of definitive beauty, but the converse does not hold. This principle goes to the root of all questions of æsthetic judgment

or criticism, and will be studied carefully later. But these remarks are sufficient to clarify the two, common, convenient uses of the term, beauty, in æsthetics and to show why no confusion is likely to arise from the two uses, once the relation between them is understood.

With these preliminaries in mind, we can proceed to develop our æsthetic theory. I shall begin at the heart of the matter by offering a definition of the æsthetic field. The justification of this definition, so far as it is presented here, will be simply what can be done with it, its explanatory power, its capacity to cover the facts. But the full justification, as I have said, must be sought for outside the æsthetic field in the whole philosophy that supports the theory. The theory is better justified, I believe, than the following chapters will be able to show, even if they should be as successful in exposition as I could hope.

CHAPTER I

ÆSTHETIC QUALITY

THE æsthetic field is that of the quality of events. Great beauty is great enhancement of quality. Though this definition of beauty is becoming more and more familiar, it still needs a good deal of clarification, especially as the use of the term, quality, is somewhat unusual in its present application. Let us begin with a simple example of an æsthetic event.

I am sitting and looking at a Japanese print on my wall, a print from Hiroshige's Tokaido series known as *The Shono Station.* An event occurs in which I am aware neither of a separate self, nor of a separate picture, nor of a wall, nor of an intervening space. What I sense is a rectangular composition of opposing forms on the diagonals, with vigorous movement leftward, upward, and inward, contrasted with various contrary movements as foils. I sense a driving rainstorm, and wet trees in receding rows bending in the wind, becoming dimmer and

dimmer in the distance. I see thatched roofs of a village and feel the shelter beneath them. I see two people hurrying down hill for shelter, and others with a palanquin laboring up the hill journeying out into the storm. I hear the swish of the wind, and the patter and plop and squash of water. Excitement spreads over the scene and curiosity and suspense and a touch of the comic too from watching the effects of the storm on trees and men. Something also there is arising from the force of the wind and the driving rain and the feeling of height and distance that is close to sublimity. If it were not for a sense of the impalpable presence of the artist and his obvious amusement at the travelers' predicament and a certain slightness of treatment, the scene could be called sublime. If we were hunting for a phrase to describe briefly the total feeling of the print, we might settle upon—'humorous sublimity.'

Something of this sort is what I experience as I look at Hiroshige's print. It has taken me some minutes to describe the details. The experience, however, took only a few seconds, for I am very familiar with the print and its effects

have been funded so as to register in me almost instantaneously. The perception constitutes a single event.

Now there are two ways of considering this event. One is to analyse its structure, to enumerate the details, and to show how these are related to one another and to other objects outside the event. The emphasis here is on relations. The other way is to feel the event as a totality. And this is the way that yields quality.

There is no method for defining quality, since it is an ultimate notion or category in contextualism. But two things can be done. We can show the connection between this category and other relevant categories, and we can point to instances of the occurrence of actual felt qualities. We shall do a little of both. The most feasible way of doing these two things appears to consist in exhibiting three important steps in the analysis of an actual event. The exposition of these steps will show the connection of the notion of quality with other relevant categories, while the constant allusion to an actual event will furnish instances of the occurrence of felt quality. The actual event to which we shall con-

stantly allude will, of course, be my æsthetic perception of the Shono print, the perception just described.

The three steps of exposition will consist in an examination of (1) the given event, (2) the physical conditions underlying the given event, and (3) the individual object of which the given event is usually only a partial revelation. We obtain our æsthetic experience in the given event, but this experience rests upon certain physical conditions, and these in turn make possible the particular object of the æsthetic experience, which we commonly call the work of art. We must go through these three steps for a full understanding of the nature of æsthetic experience. We shall consider them in turn.

(1) *The given event.* There are two aspects of a given event, the relational and the qualitative. The method of knowing the relational aspect is called *analysis*. The method of knowing the qualitative aspect is called *intuition*. These two aspects are complementary and opposite. They are complementary because neither can get along entirely without the other. Unless there were some intuition of the whole to be

analysed, there could be no analysis; and unless there were some details in relation, there could be no whole intuited. But these two aspects are also opposite, for analysis has a centrifugal effect upon an event, while intuition has a centripetal effect.

Consider the perception of the Shono print. The experience occupied only a few seconds. Yet to describe it I had to go into a number of details, which took several minutes. How is that discrepancy to be accounted for? Furthermore, the description of the details, however faithful, does not give the intuition—at least not my original intuition. Yet those details were, I am quite sure, the very details included within that intuition.

The explanation of these discrepancies is that the intuition has been analysed away in the itemizing of the details and yet there is no method of describing an intuition except by means of details. A description of a knowing process, therefore, is always by means of an analysis, so that, in description, our attention is always directed upon an analysis and away from an intuition. Nevertheless, as the brevity

of the perception itself shows, the perception of the print must have been largely intuitive. It was an intuition, of course, of the details, but not detail by detail. It was an intuition of the details in the totality.

Moreover, the details were to a high degree *fused,* so as to produce a total quality which, to speak truly, both was and was not a combination of the details itemized. Take 'trees bending in the wind,' which was one of the items noted. Attend for a moment to only these particular representative forms and consider them as one perception. Here are broken angular gray forms of successive convex and concave curves, and into these lines and shapes and colors filter associations of wind and leaves and stems. Now, 'trees bending in the wind' is a phrase for all of these details just named. The lines, forms, colors and associations are all implicit in the phrase 'trees bending in the wind,' but 'trees bending in the wind' is not merely the combination of these details. These details come all together and interpenetrate in a swift perception. There seems to be no better symbol to express this fact than the word 'fusion.' The mystery

of the Holy Trinity becomes in this fact a commonplace of intuition. There are many and one in fusion, both many and one, many in one. Even the term, 'fusion,' possibly overemphasizes the many, as if the many had something done to them to become one, whereas it would be as correct to speak of the diffusion of the one into the many. These remarks must not be taken as figurative. They are the literal description of the quality or character of the perception of those forms we call 'trees bending in the wind.' The quality or character of those forms in the print is a single unique thing that gathers up into itself details so fused that only subsequent analysis brings out their number and their diversity. Such an intuition of quality or character is an æsthetic fact.

Now, the æsthetic perception of the quality or character of the print as a whole is the same sort of intuition on a larger scale. 'Trees bending in the wind' here becomes an item itself fused with many other similar items into the quality of a new whole. I suggested 'humorous sublimity' as a possible phrase to denote that intuited quality. But, of course, the actual qual-

ity is nothing as abstract as the connotations of those two abstract words. The actual quality is the unique fusion of all the items that enter into it, and no phrase is adequate to present it, any more than 'trees bending in the wind' adequately presents the quality of the serrated gray forms and their associations about which we were speaking before. The quality can be had only through the intuition of it.

The field of such intuited qualities is the æsthetic field. This field has no sharp boundaries. It is consequently all the more important to bring out the contrast between the qualitative factor in events and other factors such as the relational.

As actual events occur, either the qualitative or the relational aspect may be dominant. It is possible to draw up a series of events, in which the content known is theoretically the same, but in which the cognitive attitudes progressively change from extreme qualitative intuition at one end to extreme relational analysis at the other. Actually, of course, a change of attitude reflects a change of content and *vice versa,* since the attitude itself is part of the event. But

a description of such a theoretical series may help towards clarifying our understanding of the nature of quality in the fundamental sense here used.

Let us return to my perception of the Shono print. That perceptive event was vivid in quality and rather highly fused, but it was also fairly discriminating of details. It was sufficiently discriminating for me to be able to itemize the details, and to compel me to *argue* in the succeeding paragraphs that there must have been a great deal of fusion. That perceptive event was, in other words, a balance of fusion and discrimination, or of intuition and analysis, or of quality and relations,—these being different terms referring to the same opposition. Such a balance of quality and relation obviously represents an event in the middle of the theoretical series we are considering.

Now, let us increase fusion, intuition, and quality, and decrease discrimination, analysis, and relations. Let us carry this to a maximum where all details vanish and a rich quality takes full possession of the event. Here we have pure intuition. If the quality is very intense, it is

sometimes called ecstasy. A better term is Dewey's 'seizure.' It is obviously indescribable precisely because it is pure quality. The only way to refer to it is after the manner we have just done, by indicating the steps up which it is reached. It is not a fiction. Some practical people may never achieve it, but that is their misfortune. To them we can only say that it is a sort of event which the testimony of many persons shows to be not uncommon, and that it consists of fusion carried to the limit and that no man is so utterly practical as not to have much fusion in his experience.

When pure fusion is relaxed, we are let down into the details of the event, whereupon discriminations unfold, and relations spread out, till we reach the balanced perception I had of the print. The quality in the balanced fusion of this perception is not, of course, precisely the quality of the total fusion, and yet the two qualities recognize each other as a man recognizes his image in a mirror or in a photograph, for the two events are grounded upon the same details.

If fusion, however, is still further relaxed

and an interest in analysis is increased, the event begins to disintegrate and the extreme of analysis leads into a totally different event or collection of events. In other words, increased interest in an analysis of the details of an event and a following out of the relations involved in the structure generated by these details, inevitably lead us into events far removed from the event being analysed. Such is the paradox of analysis. Complete analysis is the explanation of something in terms of something else, and the further analysis is carried the more remote it seems to be from what it is about.

An examination of this series brings out an important point for this theory that cannot be overstressed, namely, that the æsthetic experience is a species of knowledge. For knowledge cannot be identified with analysis (except by arbitrary definition, in which case another word like 'cognition' would have to be drafted to cover 'knowledge' and 'intuition' as two forms of 'cognition'). Intuition is as informative of the nature of things as analysis. The knowledge of an event slips imperceptibly from one cognitive attitude to the other and the virtues

of the one are the shortcomings of the other.

Analysis, as we said earlier, is centrifugal, and here are both its virtue and its fault. It informs us of the connections among things. It gives us range, and through range a power of prediction and a control over nature. For this reason it is of great practical value. But the substance of analytical knowledge becomes more and more symbolic and relationally formal the further it extends. For though a physiologist's description of the musculature of an animal might be mistaken for an immediate perception, a physicist's formulation of the structure of an atomic nucleus is obviously entirely symbolic. Through analysis we acquire range and practical power in knowledge at the sacrifice of immediacy, yet the beginning and end of all knowledge is immediacy. For without immediacy—without actual seeing, hearing, touching—the analytical knowledge of science would float in a cognitive vacuum. It would be pure mythology, and not knowledge at all.

It is intuition that furnishes immediacy. Intuition is centripetal. Precisely because it is in this way the opposite of analysis, it is able to fill

in the hollowness of analysis. It gives the actual feel and quality of events. In the intuition of quality we find ourselves immersed in nature. The æsthetic experience, therefore, being just this vivid sense of the quality of an event, is by no means, as some appear to believe, a superfluous emotional reaction telling us nothing about the world we live in, and a sort of cosmic luxury. On the contrary, it is the most illuminating of activities. It gives us direct insight into the nature of the world. It shows us what is real there, it realizes events. To feel the quality of an event is to feel the actual working of a part of the world process. It is to stop swimming and rest upon a wave, and feel the cosmic currents, and the movement of the world swell. Art is thus fully as cognitive, fully as knowing as science, so that contextualists are fond of calling the intuition of quality a *realization*. If scientific, analytical knowledge has scope, it nevertheless lacks intimacy and realization. The artist like the scientist is a man whose function it is to lead us to a better knowledge of nature —not, however, by showing us how to control her, but how to realize her.

One more important point in this connection remains to be made. A given event is continually undergoing change. We must not settle into the thought of it as something static, even though the very act of naming it seems to stop it and freeze it. A given event is a section of continuous duration or temporal flow. Quality is continually changing, now gradually, now suddenly, according to the structure of events. Events in all their details and in themselves are processes. A line is a process, an area of color a process, a combination of line and color a combined process. My perception of the Shono print was a process combining many processes.

It will be convenient to have terms to designate the relations of processes to one another as the contexualist conceives them. Let us call processes, strands, and a set of interrelated strands, a texture. A *strand,* then, is a single discriminated process. A *texture* is a connected pattern of strands. Further discrimination of a strand may reveal it to be a texture in its own right composed of still finer strands. And a texture may assume the function of a strand in a still larger texture. The analysis of a texture is,

accordingly, the singling out and the following out of its strands, while the intuition of a texture is the realization of its fused quality.

Any single texture, such as the given event we have been considering, does not exist in isolation. It has connections through its strands in all directions. Some of these connections are essential to a full understanding of its analytical nature. We call them physical conditions. They are mainly inferential and not discoverable by direct discrimination of the details of a given event.

(2) *Underlying physical conditions.* When I commenced the description of my perception of the Shono print I said that I was sitting in a chair and that there was a print on the wall, and I stressed my unconsciousness of these two facts during the æsthetic perception. To become aware of myself as a sitting object would be a distinct and different perception. Likewise, to become aware of the pigment-stained rectangle of paper on the wall would be still another distinct and different perception. These two perceptions have in fact nothing whatever to do with the æsthetic perception of the print. They

are, however, the kind of perceptions that initiate a study of the physical conditions. It is through such perceptions and a great many others like them that we learn about certain underlying textures which determine the nature of that qualitied event which we have found to be the æsthetic perception of the print.

Through physics and chemistry, we can obtain a great deal of information, should we desire it, of the structural nature of the paper and pigments which constitute the physical print, as we call it, on the wall. This information, however, is all in the form of relations. These relations gathered from experimental observations and summarized in charts and tables and symbolic formulæ are quite sufficient to justify us in inferring the existence of a physical texture on the wall even when nobody is looking at it. We infer the existence of a texture there in constant interaction with a physical environment.

It is strikingly noticeable, however, that this information tells us nothing about the quality or qualities of that texture. The information is entirely relational, and tells us only about

strands which pass in and out of that texture. This information is for the most part so remote as to be statable only in terms of numerical relations derived from the effects of these strands upon textures of a totally different nature.

Exactly the same is true of my physical organism seated in the chair. Physicists, chemists, anatomists, and physiologists can give us a great deal of relational information about my physical organism. We can infer the existence of a texture in the chair which also is in constant interaction with its environment. The terms in which these relations are stated are also for the most part numerical.

Furthermore, on the basis of this same relational information, we are justified in inferring that both of these physical textures, the physical print and the physical organism, have a high degree of historical continuity. The physical texture of the print on the wall today is almost certainly continuous with that of the print on the wall yesterday and so on back to the Japanese craftsman who laid the paper down on blocks wet with pigment and pulled off the print

in its present pigmented structure. Similarly, we are justified in inferring a continuity in the texture of the organism seated in the chair.

But with all this information we are not justified in drawing any conclusions about the qualities of these textures until they actually interact upon one another in the production of what we have been calling the æsthetic perception of the print. And here the extraordinary result appears, that since the qualities emerging in this perception result from an interaction of both these physical textures, the qualities cannot be ascribed exclusively to either texture, but only to the common texture which forms through an interweaving of the strands of both. Yet the qualities of this common texture must arise almost entirely from the fusion of strands derived from these two physical textures.

If we call the physical organism a personal texture and the physical print an impersonal texture, then the texture of my perception of the print is a personal-impersonal texture. What I naively call the qualities of the print, therefore, are really qualities of this personal-impersonal texture. The blue of the coolie's loin-

cloth in the print, for instance, is a quality which can be ascribed neither to the impersonal texture of the print nor to the personal texture of my organism, but only to the personal-impersonal texture which consists of an interweaving of strands from these two continuous physical textures. I turn my eyes away, and that personal-impersonal texture with its blue vanishes. I turn my eyes back, and that texture reforms together with its blue. The blue, as also the fused and funded quality of the whole æsthetic print, depends for its existence upon the formation of the personal-impersonal texture which carries it. And that texture lasts only as long as the physical organism and the physical print interlock in an act of perception.

The perceived character of the Shono print is, therefore, just as much a revelation of myself as it is of the print. In this sense all qualities are relative, and all æsthetic experiences. The qualities of this print, or of any æsthetic object, are a co-operative result of an interaction between a personal and an impersonal continuous texture. These qualities, accordingly, owe such continuity as they have to the con-

tinuities of the physical textures which co-operate to produce them. That is why it is so important not to neglect the physical conditions of æsthetic experience. These conditions are the sole ultimate anchorage of the experience. As that anchorage, they justify and explain the individuality of a work of art such as the Shono print. They account for a sense of continuity which runs through my successive perceptions of the print, a continuity essential to the stability of any æsthetic experience and to the very possibility of art.

(3) *The individual object.* An individual work of art such as the Shono print is a progressive coupling together of many single perceptions. Each of these perceptions is a given event, and each of these events has its own unique quality slightly different from every other given event, even from the immediately preceding perception of the same print. What we need to understand now is how I can affirm that such a train of perceptions is of the *same* object, when each perception has a different quality.

There is no question about the facts. I am

looking at the Shono print, and at this moment
my attention is on the hat of the leading figure
climbing up the hill, next moment it is on the
diagonal of the trees bending in the wind. The
quality of these two perceptions, the given event
quality, is different in the two cases. The curve
of the hat is vividly central in the first event
quality; the line of the diagonal in the second.
Yet I sense the close connection of these two
events and feel justified in calling them events
in the same object. That is, I feel a unity of
quality or character specific to the whole train
of my perceptions of the print. For when I
turn my eyes away from the print to my electric
heater, for instance, I become vividly aware of
the change of quality. But I can recapture the
original quality by looking back again at the
print. I sense that the strands which have been
separated now reconverge, that the original tex-
ture forms again, and that the quality I missed
suffuses the whole once more. Yet the new per-
ception has an event quality quite new and toned
in this instance by the very fact of its contrast
with the preceding felt quality of the electric
heater. It is this acknowledgment of the quality

or character of an individual object, carrying through a multitude of distinct perceptions each with its own unique event quality, that now remains to be explained.

The explanation lies in the recognition of what I shall call *relationship quality*. This must be distinguished from *event quality*, which is the quality of any given event, and is the only quality that we have been talking about so far. Nearly every event (and perhaps every event) contains relationship quality as part of its event quality. Relationship quality is the sense of specific relationship connecting events and connecting details of events. As a mode of cognition, the attitude which acknowledges it lies between intuition and analysis, and might aptly be called intuited analysis.

There are two important types of relationship quality: one discloses what is commonly known as similarity, the other what is commonly known as individuality. Similarity, on analysis, consists in two or more textures having strands which converge, or tend to converge, upon another texture or upon a strand of another texture, which is said to be common to the first two

textures. Thus all the chairs in this room are similar because I can sit in any one of them. They all have strands leading into the texture of my intention to sit down. They are alternative or substitutable stimuli. The feeling of this relationship among these particular objects in the room is the feeling of a chair, the sense of the quality of chair. When I want to sit down I generally act on this feeling alone. I do not generally stop and think of the various separate relations involved in the act of sitting down and of being supported, then examine the objects in my environment to find one that will satisfy these relations. When I enter the room I sense immediately the presence of a number of chairs, the quality of chair coming to me as something quite distinct from the quality of table, rug, or light bracket. By the nature of the case, however, the relationship quality of similarity is rather thin. Of all the strands that enter into the object I am sititng upon—its colors, its lines, its proportions, its material, its finish, its bruises, its repairs—only those few strands count in its quality of a chair which serve the act of sitting. Similarity spreads a thin quality

wide and if dwelt upon tends rather quickly to reduce the qualitativeness of events. Its use is, consequently, mainly analytical, and it enters the æsthetic field only in a somewhat subsidiary way.

Not so with the relationship quality of individuality. This is the central principle of massive æsthetic experience. It involves the sense that cables of strands carry over from one event into another and another, and even when spread apart can be reassembled and spun again. What makes this carry-over possible is, of course, the continuity and flow of events. As we have said, one given event carries over continuously into the next, and if strands are noted within a qualitative fusion, they can actually be traced from event to event. This may be done quite analytically with single strands, but the sense of individuality tends to break up under analysis, and then the relationship quality tends to dissolve into dispersed relations.

The underlying ground for relationship quality is clearly the continuous physical textures of which we were lately speaking. The relatively stable continuity of the personal physical tex-

ture of my body and of the impersonal physical texture of the pigmented paper, are what render possible from time to time the reassembling of the massive personal-impersonal texture of strands, which is the individual æsthetic object, this Shono print.

We are thus able to talk about the character or quality of the print, meaning not any one perception of it, but the cumulative continuity or train of perceptions of it. For earlier perceptions have effects upon later ones, and the event quality of each successive perception becomes gradually enriched. This is called *funding*. The later more richly funded event qualities are recognized as presenting ever more and more truly the full individual quality or character of the print.

In the course of this funding process, we discover that the print is not merely one individual object but a system of individual objects. Each little man in the print, each rooftop, each spray of bamboo, each file of bending trees, each flowing line, each color area, is an individual object in its own right with its own individual quality, which may be intuited in itself, and which con-

tributes to the total quality of the whole individual print.

The effect of funding is particularly obvious in a first experience with a well-organized temporal work of art such as a symphony or a novel. Here the strands in the earlier parts of the work are skillfully gathered together to reveal progressively the total character of the individual, which stands forth at the end and envelops all that has preceded. Then connections are found and felt that had not been suspected. The importance of re-experiencing a work of art—re-reading a novel, rehearing a symphony—consists largely in catching these unsuspected connections which contribute to the individual quality of the whole. That quality once partially grasped becomes enriched with every successive experiencing of it. In a very great work of art there seems to be no limit to this progressive enrichment.

There is, however, a characteristic difference in the manner of funding between a temporal work of art and a spatial work of art. In the former, the total character is built up event by event, and the organization of strands binding

these events together comes fully to light only at the end. In a spatial work of art, a discriminating eye catches the total organization at the first glance, and by succeeding discriminations works down into the details, perceiving how these progressively confirm, and in so doing enrich and solidify, the character of the whole. A temporal work of art is developed, so to speak, inductively from the qualities of the details to the quality of the whole. A spatial work of art is developed deductively from a sense of the general character of its totality to confirmations of this throughout all the details.

But this contrast is no sooner made than it must be modified. For after the first hearing of a temporal work of art, all successive hearings are somewhat deductive, in the above sense, for then we seek confirmations and elaborations of the character of the totality which we now know. And after the first glance at a spatial work of art, we induce its total individual character from the details quite as truly as we confirm deductively the general quality of the whole. We work up and down through a work of art from detail qualities to total individual quality

and from total individual quality to details. In a complex æsthetic object, there are thus many orders of individualities. And yet because of their contextual relationships there is no contradiction nor even paradox in their being individuals in their own right and integral to an individuality which absorbs them.

All of this is involved in the notion of quality. Primarily, it is the immediate intuited aspect of an event. But since every event has a relational aspect also, the connection of these two aspects with each other cannot be neglected, even when only one of them is the focus of study. For, first, every event is founded upon certain physical conditions, which we know only as relations. Secondly, in the apprehension of the character of a work of art there is a cumulative development of many intuitions, each of which reveals the quality of a different given event, but all of which are so related as to yield the relationship quality of individuality.

Now, according to the view we are considering, the æsthetic field is that of intuited quality in either of these forms—either as the simple quality of a given event, or as the quality of

the individuality of an object in which there is a sense of continuous connection.

If beauty, then, is enhanced quality, how may we get the most of it? This question is best answered by first asking, What reduces quality?

There are three sorts of activity which tend to reduce quality: one is practical activity, another is intellectual analytical activity, and the third is regular activity. The first two have a tendency to lead out of the event in which they arise to other events. In proportion to the urgency or ardency with which these activities are carried on, the quality of events through which these activities pass tends to be drained off. An urgent practical activity arises from some serious conflict which demands immediate solution. Our aim is to get out of the situation in which the conflict arises as rapidly as possible, and we turn our attention as busily as we can away from the annoying event to events which will furnish us means for the resolution of the conflict. Our attention is not on the quality of the event in which the conflict occurs, except in so far as we have to examine that event to find suitable means to eliminate the difficulty. Our

attention is on the pursuit of the means, and we set these in place as quickly as possible to remove the conflict. In practical activity from beginning to end we reduce to the minimum the qualities of events, because the whole aim of the activity is to expunge a disrupting quality.

The same result comes about in a somewhat different way through analytical activity. This activity probably originates for the most part in practical activity. In the process of resolving a practical conflict, it is often necessary to analyze the conditions in the environment and the organism, which lead to the conflict. This analysis consists in isolating the strands of the texture of the event in which the conflict occurs, and following them out to find their relationships with other strands. Many of these relationships are summarized in practical rules of conduct, and of technique, and eventually in the formulæ and relational schemes of science. These formulæ and schemes are tools, which, if properly chosen and operated, can be reasonably expected to resolve practical conflicts which arise. This analytical activity arising out of practical need may, however, develop a momentum and interest

of its own, and be pursued quite on its own account without any reference to immediate or even eventual practical benefit. When this severance of the connection between analysis and practice takes place, then we have analytical activity *par excellence*.

It can be clearly seen that this activity quite as much as practical activity tends to drain events of quality—in fact, more, because the originating conflict in a practical event keeps up a constant reminder of a highly relevant quality in the situation, while in sheer analysis no quality whatever insists on recognition. The drive in analysis is towards regularities, laws, formulæ, schemes, systems which apply to a great range of events; and an event is said to be fully analyzed and explained when all of its strands have been traced out to these schemes. The event is then often said to be reduced to the elements and relations of the schemes.

Obviously there is a great practical and intellectual value in such a reduction. But obviously, too, the event is not literally the elements into which it has been reduced. The most that can be said is that the event is the combination and

fusion of these elements into the specific quality of that event. Even this is probably saying too much. But for our purposes it is sufficient to note that the specific quality of the event is not literally given in the analysis. The quality is dispersed as a result of abandoning the texture of the event in its integrity and following out the relations of the individual strands. Analysis, therefore, by drawing attention to the relations in which an event stands, does tend to drain the event of quality.

This effect of analysis upon beauty has often been remarked by artists and poets, "knowing well, that but a moment's thought is passion's passing bell." Their hostility is sometimes irrational and exaggerated, but in principle it is legitimately grounded. If I begin to analyze not only the paper and pigments of my Japanese print, but its more intrinsic elements such as the technical drawing of the trees, the movement of the figures, the sense of depth in the distance, the balance of the forms, I shall presently find that the quality of the painting has vanished and that I am operating with various intellectual considerations, which given head lead me to dis-

cover myself not looking at the picture at all but sitting at my desk reading a book on design and technique in painting.

How regular activity either in the form of habit, or in the form of monotony deadens quality is evident enough. Through regularity, quality, so to speak, dies in its tracks. A succession of events lacking in richness of texture, however vivid in quality at the start, soon loses its quality. In a temporal work of art, a rhythmic repetition, for instance, without relief of variety soon ceases to be interesting. But on the same principle, why is not every spatial work of art uninteresting — the same combination of spaces, lines, and colors, as long as you look at them? Because in any good spatial work, there is such richness of individual texture that the eye keeps wandering over the composition, and we do not see just the same distribution of strands from moment to moment, but we have a different event quality for each successive perceptive moment. Let the design be thin, however, and a painting or a statue becomes as dull as doggerel.

Now, these three activities for the deadening of quality being known, it would seem a simple

inference to deduce that the highest beauty is obtained by the elimination of them all and the pursuit of their opposites. Eliminate conflict, analysis, and regularity, and seek for the maximum of harmony, pure intuition, and novelty. This should be the formula for beauty. This is, if I am not mistaken, the essence of Croce's theory. The greatest enhancement of quality, however, is not obtained in this way. It is paradoxically obtained by going out and incorporating in art these very activities which are hostile to quality. What kills beauty in big doses, is its greatest stimulant in moderation.

The æsthetic problem is largely a question of how big a dose can be safely administered. A work of great beauty is, consequently, one of the most delicately balanced organisms in the world. An artist is often tempted to go a little too far and upset the balance. The public is often afraid to go far enough to reach the balance. That equilibrium which is the greatest beauty, is, one can easily see, a comparative rarity. And the remarkable thing is, not that so few are able to appreciate it, but that so many can.

In æsthetic practice, the three deadening ac-

tivities reduce to two — conflict and organization — for regularity is by and large the method of organization, and analysis is simply rendering explicit the elements of the method. Regularity and analysis are thus the convex and concave of one factor, organization. So, we need consider only two general hostile factors—conflict and organization. Both these factors, if properly controlled, contribute directly to the increase of quality; the one by vivifying the quality of an event, the other by extending its spread. These two ways of increasing beauty are, moreover, somewhat antithetical, since concentration of intensity of quality tends to reduce spread, and enlargement of spread tends to reduce intensity. The artist's problem from a practical angle, consists in finding that nice adjustment between these opposing tendencies, which produces the maximum of quality with the available materials. The means an artist employs to this end will be the main concern of the following chapters. We shall deal first with the means of intensifying the quality of events, and then with the means of spreading it.

Chapter II

NOVELTY

THERE are two factors which lead to the intensification of quality. One of these is novelty and the other conflict.

Novelty is a backhanded name for a simple fact—the fact that every event is intrinsically vivid in quality and that dullness is something which accrues through monotony and habit. It is not fundamentally the vividness of an event that needs to be explained but the dullness of it. That we should ordinarily think of the matter the other way round, as if events were naturally dull and needed vivifying, is from the æsthetic point of view a rather sad commentary on our lives. It means that our lives have become largely textures of habit, and that the sense of the quality of an event is the exception rather than the rule, and that we have to do something vigorous to jerk ourselves out of the dull rule, so that we can actually have a perception. Novelty is the name that we give either to the naïve quality of events, or to that factor which breaks up habit

and monotony, once these have set in, and which reveals the event in its quality. Quality, so to speak, is always intrinsically there in the event and never needs to be explained. What is acquired is a habit, which is laid down over the quality, and this often has to be torn off for the quality to reappear. Novelty, if not naïvely present, is the tearing off of habit.

Were there no habit, all living would be in the highest degree æsthetic and we should need no art nor any technique to make it so. To a large extent life seems to be of this kind among children. They do not understand art. Why should they? They live in beauty. We, who have grown old and stiff in habits, have to fabricate what they simply find everywhere. Our works of art are no doubt richer and deeper than any child's meandering living, but the two sets of events are so different that it is as foolish to compare them as to wish we were children again.

I believe nearly every one could confirm in his own memory Wordsworth's recollection:

There was a time when meadow, grove, and stream,
The earth and every common sight
 To me did seem
 Apparell'd in celestial light,

ÆSTHETIC QUALITY

The glory and the freshness of a dream
It is not now as it hath been of yore;
 Turn wheresoe'er I may,
 By night or day
The things which I have seen I now can see no more.

 The rainbow comes and goes
 And lovely is the rose;
 The moon doth with delight
Look round her when the heavens are bare;
 Waters on a starry night
 Are beautiful and fair;
 The sunshine is a glorious birth;
 But yet I know, where'er I go,
That there hath passed away a glory from the earth.

We do not have to accept Wordsworth's inference of immortality from these facts, but the facts are not affected by the inference. Such facts are so important for our treatment of æsthetics that I shall quote some rather long passages from Romain Rolland's *Jean-Christophe*, which are probably also autobiographical. The point is, of course, that these facts constitute the very substance of æsthetic experience, and all our mature efforts in art are guided by an attempt, so to speak, to get back to the state of mind of a child without ceasing to be mature.

These child experiences are the primitive or pure æsthetic experiences, and in so far as we can recall them or have similar experiences anew from time to time in later life, they act as a gauge of sincerity for all the complexities of art with which we are mainly concerned in æsthetics.

Here is Jean-Christophe appreciating clouds:

Sometimes he used to lie on his back and watch the clouds go by; they looked like oxen, and giants, and hats, and old ladies, and immense landscapes. He used to talk to them in a low voice, or be absorbed in a little cloud which a great one was on the point of devouring. He was afraid of those which were very black, almost blue, and of those which went very fast. It seemed to him that they played an enormous part in life, and he was surprised that neither his grandfather nor his mother paid any attention to them. They were terrible beings if they wished to do harm. Fortunately, they used to go by, kindly enough, a little grotesque, and they did not stop. The boy used in the end to turn giddy with watching them too long, and he used to fidget with his legs and arms, as though he were on the point of falling from the sky. His eyelids then would wink, and sleep would overcome him.

Notice that not only the shapes and colors and movements of the clouds enter into the qualitied

texture of the boy's realized event but equally and mingled with these oxen, giants, hats, talk in a low tone, fear, surprise, giddiness. And here are his experiences with a piano keyboard:

Now his greatest joy is when his mother is gone out for a day's service, or to pay some visit in the town. He listens as she goes down the stairs, and into the street, and away. He is alone. He opens the piano, brings up a chair, and perches on it. His shoulders just about reach the keyboard; it is enough for what he wants. Why does he wait until he is alone? No one would prevent his playing so long as he did not make too much noise. But he is ashamed before the others, and dare not. And then they talk and move about: that spoils his pleasure. It is so much more beautiful when he is alone! Jean-Christophe holds his breath so that the silence may be even greater, and also because he is a little excited, as though he were going to let off a gun. His heart beats as he lays his finger on the key; sometimes he lifts his finger after he has the key half pressed down, and lays it on another. Does he know what will come out of it, more than what will come out of the other? Suddenly a sound issues from it; there are deep sounds and high sounds, some tinkling, some roaring. The child listens to them one by one as they die away and finally cease to be; they hover in the air like bells far off, coming near in the wind, and then going away again; then when you listen you hear in

the distance other voices, different, joining in and droning like flying insects; they seem to call to you, to draw you away farther—farther and farther into the mysterious regions, where they dive down and are lost. . . . They are gone! . . . No; still they murmur. . . . A little beating of wings. . . . How strange it all is! They are like spirits. How is it that they are all so obedient? How is it that they are kept captive in this old box? But best of all is when you lay two fingers on two keys at once. Then you never know exactly what will happen. Sometimes the two spirits are hostile; they are angry with each other, and fight; and hate each other, and buzz testily. Then voices are raised; they cry out, angrily, now sorrowfully. Jean-Christophe adores that; it is as though there were monsters chained up, biting at their fetters, beating against the bars of their prison; they are like to break them, and burst out like the monsters in the fairybook—the genii imprisoned in the Arab bottles under the seal of Solomon. Others flatter you; they try to cajole you, but you feel that they only want to bite, that they are hot and fevered. Jean-Christophe does not know what they want, but they lure him and disturb him; they make him almost blush. And sometimes there are notes that love each other; sounds embrace, as people do with their arms when they kiss: they are gracious and sweet. These are the good spirits; their faces are smiling, and there are no lines in them; they love little Jean-Christophe, and little Jean-Christophe loves them. Tears come to his eyes as he hears them, and he is never weary of calling

59

them up. They are his friends, his dear, tender friends. . . .

So the child journeys through the forest of sounds, and round him he is conscious of thousands of forces lying in wait for him, and calling to him to caress or devour him . . .

One day Jean-Christophe's father discovers him playing:

Jean-Christophe, thinking he was doing wrong, quickly put his hands to his ears to ward off the blows he feared. But Melchior did not scold him, strange to say; he was in a good temper, and laughed.

"You like that, boy?" he asked, patting his head kindly. "Would you like me to teach you to play it?"

Would he like! . . . Delighted, he murmured: "Yes." The two of them sat down at the piano, Jean-Christophe perched this time on a pile of big books, and very attentively he took his first lesson. He learned first of all that the buzzing spirits have strange names, like Chinese names, of one syllable or, even of one letter. He was astonished; he imagined them to be different from that: beautiful caressing names, like the princesses in fairy stories. He did not like the familiarity with which his father talked of them. Again, when Melchior evoked them they were not the same; they seemed to become indifferent as they rolled out from under his fingers. But Jean-Christophe was glad to learn about the relationships between them, their hierarchy, the scales.

And so habit and analysis began to steal away his spirits, and make them familiar and indifferent. After that, to call them up again in their old character, he had to gain skill in composition and musicianship, in the mechanisms of novelty. It is too bad that this should be necessary. But the spirits would soon have vanished anyway, and we should be thankful that when they stop coming of their own free will, some one should have the power to invoke them.

The novelty we are talking about is not the novelty implied in the uniqueness of every event. As we have seen, the context of two events is never quite the same twice and the quality of any event is consequently in some manner always different from that of any other event, and so unique, and, in that sense, novel. This sort of novelty we had best call simply *uniqueness*. Even the most regular, monotonous, and habitual event has this sort of novelty. The novelty we are talking about is either the naïve novelty that precedes habit, or the intrusive novelty which breaks up habit. Novelty in either of these closely related senses is sometimes confused with uniqueness, for we are highly conscious of the

uniqueness of an event only when its quality is vivid. It easily seems as though an intrusive novelty produced the uniqueness of an event. But that is not the case. The intrusive quality merely brings out the uniqueness which the event has anyway. The æsthetic fact, to be sure, is the sense of the unique quality of an event. And, as our illustrations were intended to show, this quality is vividly felt intrinsically in the event, and fades only as a result of habit, analysis, practical urgency, the factors which tend to weaken quality. This unique quality is the thing to bring out æsthetically. But unless it is brought out, it will be missed. That is the very meaning of "realization."

Accordingly, the emphasis in æsthetics must be on the vividness of the quality, not on its uniqueness, and this not because the uniqueness is unimportant, but only because it can always be relied upon whereas the vividness cannot. When a work of art is criticized for its lack of individuality and uniqueness, the source of its deficiencies will usually be found in its containing too many old rules and clichés, too much habit which dulls the unique character actually there. We

resent missing the unique quality, and blame the event for lack of uniqueness, whereas we should blame it for lack of vividness. Uniqueness is, therefore, not a source of concern in æsthetic appreciation, but novelty is.

Since novelty is a term having significance mainly as opposed to habit, we are prompted to ask, What is habit? From the contextualistic point of view, the basis of habit is the connectivity of strands. If the connections are, as we say, innate or congenital, we call the connected set an instinct. If they are acquired, we call them conditionings or associations; and, if they are sufficiently stamped in or clamped together, we call them habits. The process of conditioning or clamping together, we call learning.

The psychology of learning is a study in itself, which fortunately we need not enter into, since the æsthetic problem begins after the conditionings or associations have become established and set fast. All that we need to notice is that once a habit is established, there is a tendency for the habit to regularize the events in which it occurs, to mold them into its form, and to deaden their quality. The events become mechanized. The

loss of quality through mechanization is the source of the æsthetic concern with habit. Obviously, the function of novelty is to avoid or break up this regularity and demechanize events. How is this to be done?

The simplest expedient would seem to be the plain avoidance of habits and the search for *naïve novelties*. This is theoretically an excellent method. But is it simple? Is it easy for an artist to avoid human habits? Our preliminary remarks at the beginning of the chapter have already suggested the opposite. For notice what this method consists in. It consists in acting contrary to the whole trend of our living. The biological process of growing up, of adjusting to our environment, of fitting into our society, is a process of acquiring habits — habits for dealing with every exigency, even with the surprising and unusual. The biological and social momentum is all in the direction of practical readiness for any situation. Habits grow by geometrical progression, compounding on one another. We develop habits for developing habits. Our intelligence itself is in large part a capacity for swiftly developing habits. The seeking of quality by

the method of avoiding habits demands that an artist avoid all these, and demands that he buck the momentum of his biological constitution.

Yet it can be done, and artists sometimes do it. They lead us into the presence of things we have never seen. These insights are the ground for Wilde's famous remark that nature imitates art. The Romantics showed people a beauty of mountains and deserts, Monet showed them a beauty of light, Cezanne showed them structures in trees and skies. Many schools of art have taken their origin from some artist's perception that penetrated behind habits.

But the more common, and the easier way, is not the avoidance of habit but a vivifying of the structure of the æsthetically troublesome habit itself. This can be done by setting the habit in an unusual environment, that is, by the method of *intrusive novelty*. The core of the habit is not constrained, but, so to speak, the outskirts of it are. For the limits of an established habit are hard to define. There is a tenacious core of strands and a much less tenacious fringe. We generally define the habit, if we are prompted to define it, by its core, and are fre-

quently unaware of its fringe until some unusual circumstance arises that informs us of unsuspected connections with the internal core.

Take any word. For a word is a very paradigm of habit. We define a word, that is, describe the habit in which it consists, by an inner core of meaning, which, in the last resort for most words, is what we call its denotation. But every word, even the most technical, has a fringe of connotation. This connotation may be very extensive and subtle. In what we call (rather to our peril) rich or poetic words, this fringe of connotation is obvious. But all words have it, and a full catalogue of all the little strands of habit, which constitute this fringe, is more than any man could make. Associations of sound, grammatical associations, other words that associate with it, and so on, make up the outer fringe of the habit of a word. By the simple expedient of placing a word in a strange environment, the word habit is broken up at its fringe, and the quality of the word even to its core lights up.

"Declines" would not ordinarily be considered a very poetic word. "Taking a downward direction" is one of the dictionary definitions at the

core of its meaning. See how this literal meaning glows in:

Death, that dark spirit, in's nervy arm doth lie;
Which, being advanc'd, declines, and then men die.

No strain is put on the core of the word's meaning. Yet a rather dull word becomes the coal that ignites a bundle of words. The quality of the measured movement of inevitable doom gleams over the line. And gleams through a literal, prosaic, habitual meaning of the word; gleams through the very literalness of the word itself—on account of its strange verbal environment. We do not usually speak of a warrior's sword arm "declining"; we say it "strikes" or "makes blows" or something like that. In fact, take "decline" out of its context in the line, and another meaning of the term implying weakness, deterioration, decay begins to be felt. What is involved in making this exactly the right word is something delicate and complex, involving the cores and fringes of other words. It is the interaction of the strands of the whole context. But the general principle for the evoking of the quality of the word is clear enough. It is that of

placing the word in a new environment, which breaks up some of the fringe of habit—the principle of intrusive novelty.

Though the principle is particularly evident in words, which are entirely matters of habit, it is just as vigorously operative in other materials of art. Sounds, colors, lines, tastes, smells —all things have their habits with cores and fringes. Sounds go together in scales, and chords have their habitual ways of resolving and moving into one another. A note out of the scale or in a strange sequence, an unusual modulation, an exotic timbre, or an unfamiliar variation of an old tune, will make dull tones sing. The same is true with colors and lines. Palettes get fixed, shapes get stereotyped. We are not aware of the extent of these habits, till painters like Gaugin and Matisse surprise us by breaking into them. Even a square becomes significant again, or red-white-and-blue.

But the principle can be overdone and carried so far that it defeats itself.

"O let me sip that tear!" (Keats, *Endymion.*) "Sip" breaks into the habits of "tear" and vice versa. We stop and take notice. But we do more

than notice. We begin to query: 'Sip a tear?'
What a thing to do! And what a picture! We
stand back and pass from realization into anal-
ysis and criticism. We take up momentarily a
practical attitude. If there is somebody in the
room, we may even say "Listen to this!" and
have a laugh at the expense of the poet—and of
the poem.

It is probably better for an artist (as the young
writer of this novelty perhaps proves) to err in
this direction than in that of dullness, though
the final result is about the same. This sort of
thing does imply a vitality of imagination which
may be restrained, while nothing can be done
to spur into vitality a dull academic mind. But
the moral of the example is once more that of
seeing what a delicate balance is the constitution
of beauty. Novelty must intrude into our habits
for us to realize their character, but it must not
intrude too far. How far depends upon the cir-
cumstances. It depends upon the intruder, and
upon that intruded upon. It is a matter of
æsthetic tact.

Moreover, what will be tactful for one age
may be tactless or ineffective for another.

Habits change. What was startling a hundred years ago may be matter-of-fact now. The age just past is always at the greatest disadvantage. Its novelties have become our habits, and their artists all seem dull. Mercifully, we react against them, seek out our own novelties, and forget many of their habits. A later generation rediscovers the qualities of the despised age, and the intervening ages raise up a curtain which pretty well shuts off the likelihood of another deterioration through habit. The habits of the two ages are now too different from each other for the novelties of the older age to become habits again. Some of the old novelties may be even more novel than they were in their own day.

Intrusive novelty is a sort of scintillating light that plays over the surface of life and art. No deep beauty comes out of it. It is a gentle agent which softly reminds us of the qualities of things. It is our best substitute for the fresh experiences of childhood.

Chapter III

DRAMATIC CONFLICT

THE enhancement of quality, we said, is brought about by the factors of novelty and conflict. The division of these factors is somewhat arbitrary. For there is first the fresh event intrinsically glowing with quality. Then habit sets in, and there is search for fresh events in the interstices of the thick mesh of habit. Then there is the intrusion of one habit into the fringe of another making the event glow by a suppressed and hardly noticeable conflict. Then (the subject of this chapter) there is the violent conflict of habit against habit or against some other obstacle, the core and the whole texture of the habit rising up in combat against the obstruction. We cannot say in the complicated development of life where one of these stages ends and the next begins. But there is a great difference of feeling between a clear case of fresh novelty, or of intrusive novelty at the

fringe, and a clear case of thoroughgoing conflict. The first is in the manner of a glow of quality suffusing an event, the last is in the manner of an eruption of quality.

Conflict is an extreme case of intrusive novelty. But it is an extreme so great that it normally turns at once into urgent practical action. It is, consequently, a condition intrinsically hostile to beauty. There is no denying the blaze of quality resulting from an intense moral or physical conflict, but the whole mechanism of life is organized to drive a man to the swiftest possible solution of and relief from the burning (just the word) and insistent problem. Practical action shortens as much as possible the duration of the quality of the conflicting event, and moreover leads immediately out of the event to other quieter events instrumental to the solution of the conflict.

In conflict, however, the artist is quick to perceive an agent of great æsthetic value, if only it can be tamed and harnessed to serve his purpose of continued intensification of quality and not permitted to bolt to safety. Like fire, it may be confined and induced to warm its maker, not

left free to consume him. The greatest art, with few exceptions, is composed of this inflammable and flaming material.

The more violent and extensive the conflict, provided it can be controlled, the greater the potentiality of quality. Now, one of the most tenacious and compacted organizations of strands is what we commonly call a purpose. A purpose is organized not only widthwise but lengthwise; that is, not only does it gather into itself a multitude of present energies, but it lays down an articulated plan into the future. Think of a man wooing a girl, or of a girl pursuing a man. There is an end in view, there is a drive behind, there is a conscription of present energies, and a deploying of them into the future, there is a powerful organization and a tremendous concentration of vitality. Set one such purpose in conflict with another, and we have the highest potentiality of intense quality at our disposal. No wonder love is the predominant subject matter of literature.

The inflammable potentialities of a purpose, that is, the spread and intensity of quality it can produce, depend partly on the tenacity of its

drive, partly on the strength of the obstacles placed in its path, partly on the capacity of the organism to muster its faculties for the problem. Hunger, love, jealousy, fear, hate, ambition, and the like are powerful drives, as compared, let us say, with the desire for a seat at a concert, or for a new hat. The first set is tenacious enough to drive a man sometimes to his destruction. The second pair would hardly lead a man or a woman as far as that. Quite apart from the intrinsic intensity of the tenacious drives, these possess a lasting power which permits of a linking together of many events, a power which the weak drives do not have. But obviously, one does not æsthetically make the most of a tenacious drive unless one places sufficient obstacles in its way to force it to extened itself through time. And, lastly, there is no great sidewise spread of quality unless the organism has the resourcefulness to vary its attacks on the obstacles presented, or the moral endurance to stand up against a variety of attacks, or both.

The ideal æsthetic material, then, seems to be a rich, resourceful, and strong personality stirred by a powerful drive to some end, in the

way of the attainment of which resistant and stinging obstacles are placed. The character must furthermore be depicted as vividly aware of his aims, and of the struggles and sorrows which the obstacles force upon him, so that the quality of the purpose in its progress and in its obstruction will be deeply realized. That is the material of high æsthetic intensity, the very material of our most serious practical life. How is it to be kept from running away with us and becoming æsthetically unmanageable? How is it to be restrained for æsthetic purposes?

The answer is, by means of what are called æsthetic conventions, which have been built up through the æsthetic experience of ages. In the first place, the purpose, which is to be obstructed, is not implanted directly in the appreciator but only indirectly. It is not we ourselves whom the artist causes to love a radiant maiden, in order that an insurmountable obstruction may be thrown in the way of our desire, in order in turn that we may have full appreciation of the quality of the experience. Flirtation often does commence in something of this spirit. But the trouble æsthetically with flirtation is either that

it becomes presently much too serious and practical, or that it is not nearly serious enough. Moreover, the course of a flirtation cannot ever be controlled to the best artistic advantage by the most expert artists.

The lover and the maiden, therefore, are indirectly and, as we say, imaginatively implanted in us. They act on a stage, or come to us through the symbols of a page. This expediency has many advantages over the direct experience, one of which, strangely enough, is diminution of the intensity of the purpose. The powerful drives, at full intensity simply cannot be kept from bolting into practical action. They are, as we say, too painful to be endured, which probably means simply that they are too strong to be held in contemplation. For though we can often learn in later life to contemplate and absorb the quality of many conflicting events which in earlier life we flee (for the sad ending is something of an acquired taste), there is an intensity of conflict based on any of the main drives which will not bear contemplation, and which it would injure and perhaps kill us to contemplate. The planting of conflicting pur-

poses, therefore, not directly among our pur-
poses of the day, but in our imagination, renders
feasible the æsthetic use of types of conflict with
a degree of seriousness, which could not other-
wise be æsthetically endured.

Furthermore, the physical conditions of the
stage or of the printed book inhibit practical
action automatically, even if this should begin
to take place. The only practical action a man
can take with a book is to shut it. At a theater,
all he can do is to hiss or cheer, or go away.
Inhibitions like these set up against practical
action in situations that normally call for it, are
sometimes called "psychical distance." The con-
ventions of the theater, for instance, of which
there are many, the elevated stage, the lighting,
the three-sided room or the abstract presenta-
tion, the actors' orientation toward the audience,
the expert diction, the concentration of action,
the break between the scenes, etc., are all means
by which the artist controls the situation and
holds the spectator in place.

These conventions are the instruments by
which the artist controls conflict. They are not
absurd. The realist who ridicules them or tries

to avoid them, does not know what he is trying to do. If he could succeed in his aims, he would ruin his art. For he would turn his art into moral action. The more serious the conflict and consequently the more imminent the tendency to practical action, the greater the need of abstraction or convention. And conversely the more intricate the technique of conventions the more an artist can spread out, develop, and dwell upon his conflict.

Suppose we briefly examine one of the great illustrations of this technique—the first two acts of *Macbeth*. The plot of the play is a simple story of political ambition, murder, and the consequences. But the substance of this work of art is the realization of every articulation of the purpose and of the struggle to avoid the consequences. What we wish to notice is the means by which Shakespeare imaginatively builds up in us the drive and the intent, gives these vividness, and yet holds us back to feel every step in the conflict.

Moreover, once the drive and purpose is strongly initiated in the reader, the artist's own refusal to progress rapidly in his story consti-

tutes an obstacle in itself and a conflict on its own part between the writer and the reader which has its own power of vivification. We call this sort of conflict suspense. There is thus a double source of conflict to observe, that generated through the represented purpose, and that generated by narrative suspense. The two cooperate magnificently to vivify each other. For narrative suspense functions as an artist's convention in the restraint of the represented action; and the represented action acts almost as a restraint upon the writer's narration. For the action seems to say, "Come on! Come on! Tell the story!", while the purpose of the writer mumbles, "I've got to get the most out of you. I've got to get the most out of you." And this itself is a conflict with its own benefits of qualitative enhancement.

To come to *Macbeth*. The play opens with the scene of the witches. Here the seed of ambition is planted. In an atmosphere of gloom and deviltry symbolic of a cosmic moral conflict of good and evil, an agent of the devil speaks:

First Witch: All hail, Macbeth! hail to thee, Thane of Glamis!

Second Witch: All hail, Macbeth! hail to thee, Thane
 of Cawdor!
Third Witch: All hail, Macbeth! that shalt be king
 hereafter.

Macbeth is deeply affected and speechless and
for eleven lines Banquo holds up the action and
dilates upon Macbeth's state of mind:

Banquo: Good sir, why do you start, and seem to
 fear . . . etc.

Then the witches make predictions about Ban-
quo. And then bursting into speech, Macbeth
expresses the state of mind Banquo had already
described:

Macbeth: Stay, you imperfect speakers, tell me
 more:
 By Sinel's death I know I am Thane of Glamis;
 But how of Cawdor? the Thane of Cawdor
 lives,
 A prosperous gentleman; and to be king
 Stands not within the prospect of belief
 No more than to be Cawdor. Say, from whence
 You owe this strange intelligence? or why
 Upon this blasted heath you stop our way
 With such prophetic greeting? Speak, I charge
 you.

The witches vanish and for ten more lines Ban-

quo and Macbeth expound upon the prophecy. Then enter messengers from Duncan, the king, announcing Macbeth as Thane of Cawdor. The former Thane of Cawdor has been convicted of treason, and Macbeth is now Thane of Cawdor. The seed the witches planted grows fast. Here is confirmation of one prophecy, and Banquo has been present to prove that the prophecies were not fantastic imaginations. Macbeth and Banquo interchange comments on the matter, and again the action is stopped by a soliloquy:

Macbeth: Two truths are told,
 As happy prologues to the swelling act
 Of the imperial theme . . . etc.

By now the purpose is well initiated, and a strong drive established, and the personality involved is seen to be resourceful and heroic, for we have casually learned that the honor Macbeth received as Thane of Cawdor was rightfully due him for a victory over "the stout Norweyan ranks." His heroic and reputable character already aggravates the gathering moral conflict with his ambition to be king. The materials are all here for vivid and rich realization.

Promptly it comes. Duncan will stay over night in Macbeth's castle. Lady Macbeth is introduced reading a letter from Macbeth telling her of his encounter with the witches and the succeeding events. She now becomes the incarnation of Macbeth's evil conscience. And there follows the great scene where all action is stopped, and the conflict between Macbeth's better self and his ambition is allowed to burn and blaze. First there is a long soliloquy. Shakespeare makes it as long as he dares, lifting it with every trick of intrusive novelty that language will bear, to restrain our impetuous desire for action.

> *Macbeth:* If it were done when 'tis done, then 'twere well
> It were done quickly. . . .

There is no need to repeat these well-known lines. But let me note the last, which are the theme of the whole play, and have a verbal vividness suitable to their function:

> I have no spur
> To prick the sides of my intent, but only
> Vaulting ambition which o'erleaps itself
> And falls on the other——

DRAMATIC CONFLICT

Perhaps the most famous wrenched metaphor in the language. It is more than intrusive novelty in words, it is a dramatic conflict in itself. The metaphor is pushed so hard that it jams with itself, and contributes to its own obstruction for eruptive quality. The passage that precedes is so rich in quality, that nothing short of such violence could have been a climax to it.

Lady Macbeth enters and Macbeth says:

> We will proceed no further in this business:
> He hath honored me of late. . . .

Whereupon the matter of the soliloquy is all gone over again in the dramatic form of Lady Macbeth arguing her husband down. She is, of course, successful and the scene ends with Macbeth summarizing the conflict and his determination:

Macbeth: I am settled, and bend up
Each corporal agent to this terrible feat.
Away, and mock the time with fairest show:
False face must hide what the false heart doth
 know.

Even so, the murder does not yet take place.

There is a scene in the courtyard of the castle. Banquo comes in:

Banquo: How goes the night, boy?

We learn that the moon is down and that it is twelve o'clock. Banquo gives utterance to vague anxieties. Macbeth enters, and the two talk about the prophecies. Banquo goes off to bed. Still the murder does not take place. Shakespeare will not let a particle of realization pass unutilized. Here comes another of the great Shakespearean soliloquies:

> Is this a dagger which I see before me,
> The handle toward my hand. . . .

Forty lines, and then Macbeth goes out and performs the deed.

Well, that is the artist's way of handling conflict. He builds it up to the highest proportions he can, and continually holds it before us in those proportions. It is not for him something to be resolved, but something to be tasted. If he resolves it, the reason lies in the movement of the purposes themselves. They require resolution. The artist as artist prefers not to resolve

them. You feel Shakespeare, the artist, putting off the murder as long as he can. He wants to make the most of the vividness generated by the strain. The purpose finally drives him to the deed. Fortunately, the deed in this case only aggravates the basic conflict and the play goes vividly on. And the conclusion of the narrative is right after a great artist's heart, not a solution of the problem of the represented conflict at all. That conflict got beyond all possible solution. The end of the story is an inevitable calamity, so that there is vivid realization to the last scene. I mean the action lends itself to realization up to the last scene, and the vitality of the end does not depend upon some clever turn of thought or word to compensate for the usual dullness of usual solutions.

The result is that there is no problem of tragedy. There is no mystery or paradox in the evident preference of great artists for tragic subjects and in their evident will to dwell upon and expand upon every detail of misery and struggle. No need of ingenious theories of catharsis, sublimation, concealment of pain under wreaths of charm, stoical facing of pain

in the pursuit of truth, transmutation of values, just punishment of the wicked. These motives often play their part. But the fundamental reason that much of the greatest art is tragic, is the rich field of realization furnished by the obstruction and conflict of strong purposes.

Dramatic conflict is most easily exhibited in the novel and the drama. There it is revealed in its anatomy and developed in the customary social terms. But there is no type of art that does not employ it. Music, especially our occidental music composed within a system of scales soaked in tonality, where a "yearning for the tonic" and for many other subtler relations has been cultivated and bred into our ears for generations, is intrinsically only slightly less dramatic than the drama. Tones develop purposes as well as do bodily actions, and the composer builds up these purposes and obstructs their solution and dwells upon the events realized by the conflict as fondly as the dramatist. Music is almost as thoroughly an art of suspense as literature.

The saying that architecture is frozen music is but a striking way of calling attention to the

non-representational dramatic qualities of this art. The drama here is among gravitational and stress forces and among lines, surfaces, and volumes. The importance of the theory of empathy lies in the insight that unless the spectator enters into and feels these forces imaginatively in a building, just as he feels the purposes of the characters in a play, he misses much of the æsthetic quality of a building—perhaps all of it. The architect marshalls his forces differently from a composer or a dramatist. He extends his conflicts through space instead of through time. But the rise of a high wall, the thrust of arches, the counter thrust of buttresses, the expansion or contraction of interior volumes, the serenity of smooth surfaces, and the restlessness of neighboring decorated surfaces, the expectations of the interior functions set up by the exterior functions and the suspense produced by the wall which temporarily conceals the one from the other, the gradual unfolding of the total plan delayed by the very necessity of walking round the building and through it—all these render architecture also an art of suspense and dramatic conflict.

Similarly with sculpture and similarly with painting. Furthermore, there is no art that is not susceptible of emotion. And, as we shall see presently, emotion is the very spirit of dramatic conflict.

Chapter IV

EMOTION

EMOTION is the most intimately felt and the least satisfactorily understood of all objects of experience. Everyone knows emotion, yet no one seems to know what it is. It baffles analysis and yet lies in our bosoms. The paradox, I suggest, disappears, if we recognize that emotion is the very essence of quality. It is the very quality of the event itself when this event is voluminous, intense, and highly fused. It is, in short, a relative term and its correlate is analysis.

At one extreme is cold analysis, which drains the quality out of an event and leads off into the compartments of systematized conceptual schemes. At the other extreme is pure fusion of quality which insulates an event from other events, as far as such insulation is possible. We do not, however, generally call a fused quality an emotion unless the event in which it occurs is massive and intense—unless, that is, many

strands are involved and driven well up into the focus of the event. An extensive fusion spread out over the fringe and lacking in intensity and concentration, we are likely to call a mood. If there is concentration of quality, but no great massiveness or intensity, we call it sensuous feeling. Absorption in the violet of a night sky would be sensuous feeling. The spell of a soft evening saturating thought, movement, and utterance would be a mood. A surge of passion such as inspired Shelley's "Swiftly walk o'er the western wave, Spirit of Night" would be an emotion. If sensuous feeling acquires intensity, it rapidly gathers up extensity and turns into emotion. The same with mood. There is only a difference of degree among them.

We accept, therefore, James's theory of the emotions, only enlarging the theory to take in not only bodily sensations but any sensations, and insisting more explicitly than he does on the fusion. "What kind of an emotion of fear," he writes, "would be left if the feeling neither of quickened heart-beats nor of shallow breathing, neither of trembling lips nor of weakened limbs,

neither of goose-flesh nor of visceral stirrings, were present, it is quite impossible for me to think. Can one fancy the state of rage and picture no ebullition in the chest, no flushing of the face, no dilation of the nostrils, no clenching of the teeth, no impulse to vigorous action, but in their stead limp muscles, calm breathing, and a placid face? The present writer, for one, certainly cannot. The rage is as completely evaporated as the sensation of its so-called manifestations, and the only thing that can possibly be supposed to take its place is some cold-blooded and dispassionate judicial sentence, confined entirely to the intellectual realm, to the effect that a certain person or persons merit chastisement for their sins" (Psych. vol. ii, p. 452).

The emotion of fear and the emotion of anger are the fusions of these sensations. That is to say, fear and anger are fused qualities which upon analysis resolve themselves into these elements of discriminated sensations. We must add, however, that it is not only these internal sensations and muscular sensations that are involved in the quality of the emotion but quite

as much the external visual, tactual, auditory, olfactory, and gustatory sensations in so far as these do enter into any simple event. Fear of a bear, fear of thunder, and fear of a worm in an apple, are quite specific emotions in which the qualities of the so-called external sensations are as intimately involved as the so-called internal sensations. Moreover, if we are going to be thoroughly analytical about the matter it is not only the sensations that are involved but also their relations to one another in the total situation. As someone has pointed out in this very context, a chained bear does not stimulate fear.

The internal and muscular sensations do, however, seem to have a certain preponderant importance in the analysis of emotion, in that these are the sensations of drive and activity. They seem to be the source of that intensity and concentration which are essential to emotion as distinct from mere sensuous immediacy. And those emotions are particularly powerful which have developed within certain patterns of action essential to the life of the organism. McDougall's attempt to pair off emotions with

instincts was based on an important insight, however unacceptable the theory in detail. For patterns of action are purposive organizations of strands drafting in not only the energies of the organism but the structure of its environment, and concentrating these upon an end. Here is massiveness of material, concentration, and potential intensity—the very substance of emotion. The more highly practical and essential to the life of the organism is the pattern of action, so much the greater the potentiality of emotion.

Once more we meet that insistent paradox, that the most powerful æsthetic material is to be found in those activities intrinsically most hostile to æsthetic quality. For there is nothing more practical than a pattern of action vital to the preservation and well being of an organism —nothing more practical than love, hate, jealousy, fear, disgust, pride, anxiety, and in another way shame, contrition, sorrow, despair.

How are these materials to be brought into the service of æsthetic quality? Of course, through the agency of conflict. This is another factor in emotion which James's theory does

not sufficiently stress. Once the emotion is upon us in its full intensity, we may be able to analyze it conceptually into its sensational and relational constituents. But how did it acquire that intensity? A pattern of action is a habit and tends to run itself off and be done. It acquires volume and qualitative intensity—in a word, emotion— only through obstruction. Block a vital pattern of action, and emotion emerges. To be sure, no sooner does the emotion arise than the natural onrush of the pattern of action tends to drain off the quality of the emotion in the pursuit of the practical end. But the emotion has been created, and thereafter all that needs to be done is to hold the habit or the instinct back so that the emotion may flame. Conflict is the source of emotion, and in the previous chapter we were talking about emotion all the time without naming it.

There we were watching the appearance of emotion as conflict brought it to the surface in the stream of time. That is why music and the drama so well served our purpose. But emotion wells up equally in static pools. There is emotion in pictures felt at the first glance, and in lyrics

which do not seem to move into conflicts. What is the source of these emotions, and where are the conflicts hidden?

The answer is a reference to those patterns of action, about which we were just speaking. We call these patterns of action expressions of emotion. They are really, as we saw, the emotion or part of the emotion itself. They are exhibitions of conflict. A child in a tantrum shows by his bodily attitudes, his cries, and the sort of things he says, the kind of conflict going on in him. These patterns of action become as familiar to us all as the patterns of colors and shapes which we call animals, trees, and insects. We learn them partly out of ourselves and partly out of our environment. When they occur in our environment, we are frequently drawn into them ourselves. An angry man makes us angry, and we wallow in a community of anger, and the patterns of action mesh into one another and constitute a mutual pattern which is not easily disentangled into two.

The learning of these patterns is of great practical importance, for they are our guides to social action. They tell us whether we can count

on cooperation, or must nerve ourselves up to opposition, whether we should offer comfort, or ridicule, or encouragement, or rebuke. We become very adept at interpreting little signs—the dilation of the eye, the curling of a lip, the contraction of a jaw, the tip of the head, the tapping of a finger, and all the modulations and rhythms of the voice. Many of these signs are the same the world over and we call them instinctive, but many differ from culture to culture. They are details in patterns of action. They betray, often with great accuracy, complicated conflicts of purposes. Assisted by other confirmatory signs, we can often sympathetically reconstruct the conflict involved and enter into it and feel it ourselves.

Added to these bodily expressions are great quantities of what we call emotional stimuli— objects, which either through our biological make-up or through our social habits, normally enter into action patterns. Such are sudden loud noises, sudden movements, a violent aggressive jar, soft noises, gentle touches, warmth, a clear blue sky, great clouds, heavy surf, moonlight, a calm lake, a sword, a gun, a thimble, a flag,

a party slogan, and all so-called emotive words. Also, there is a fine emotional discrimination among colors and combinations of colors; lines whether short and thick and jagged, or slim and sinuous; shapes whether square or blunt or pointed; tones; chords; scales whether the major or the minor mode or some exotic mode. How far these are learned or natural, no one knows, but in every culture they constitute an emotional language of great reliability for those who have been brought up in it.

Now, the point we are heading for is this, that an artist does not need a stretch of time in which to develop a conflict and its resultant emotion. Through the agency of these details of action patterns, he can plunge the spectator immediately into a violent purposive conflict and a strong emotion. And the fact that there is no temporal movement in the work of art, if, for instance, the work is a picture or a statue, acts in and of itself as a means of suspense holding the observer in the conflict without power of escape other than his own voluntary decision to turn away and look at something else. Furthermore, it permits of an intensive development

of the emotion to a degree of refinement that a temporal work of art cannot ordinarily afford to make. A dancer cannot stop to realize an attitude as a sculptor can. The emotion of a dance is superficially more obvious and compelling than that of a statue. But in the end the statue may for a sensitive man actually develop the more intense emotion.

It is not, therefore, the obvious elements of a great picture or of a musical composition that account for the enhancement of quality found there—not the mere colors, and forms, and lines, and represented figures, nor the mere pitches, and intensities, and durations—but what these carry along with them as biological and social action patterns. Under the surface, sometimes clearly seen, sometimes only felt, impulses meet and intrude upon one another or conflict and the waters of experience are filled with a radiant fusion of quality, with an emotion.

There are three technical modes of producing emotion through a work of art: first, direct stimulation; second, representation; and third, expression. In the first, stimuli are directly evocative of emotion, or details detached from

action patterns are set into a composition, which as a total stimulus arouses an emotion. This is the method of abstract design. We think at once of music and architecture. In the second, men and women expressing emotions are represented, and our emotions are stirred at perceiving the expressions of these represented emotions. Here we think of the novel, the drama, the representative picture, and the statue. In the third, signs of the artist's own emotions appear in his work of art, and our emotions are stirred at the exhibition of his emotions. Perhaps here we think particularly of the lyric.

All three modes may be mingled in one work of art. But the first two modes used alone or preponderantly produce art which we call objective, the third art which we call subjective. There is no good æsthetic ground that I can see for preferring one mode to another. There are great works in each mode and in all sorts of combinations of them.

Furthermore, the emotion evoked in the spectator through any of the foregoing modes may be either an emotion *with* or *at* the emotions exhibited in the work of art, or may be a com-

bination of the two. To feel emotions *with* the emotion exhibited is, of course, to accept the direct stimulation of the first mode; to sympathize with the emotions represented according to the second mode (feel angry as the characters show anger, feel a little afraid as they show fear, etc.); or, according to the third mode, to enter into the expressed emotions of the artist.

To feel emotion *at,* however, is a more complicated activity in each case. To feel emotion *at* directly stimulated emotion, according to the first mode, is likely to be detrimental to the appreciation of the work of art concerned; as also to feel emotion *at* the expression of the artist according to the third mode. For in each of these cases, the activity seems usually to involve a retreat of the spectator from the work of art and a critical judgment whether of admiration or irritation or disgust or even moral indignation. But the quality of these emotions is not a realization of the event of the work of art but of another event, merely instigated by the work of art. Furthermore, they are all highly practical activities, leading rapidly off

into action. Except in the humorous and the comic, an artist cannot safely lead his audience to feel emotion *at* the emotions he evokes according to the first and third modes.

But in the case of the second mode, that of represented emotion, feeling *at* the emotions represented is often necessary, for several different emotions may be simultaneously represented, and it would be impossible to sympathize with all of them at once. Generally the artist leads the spectator to feel *with* the emotions of one character, the principal one, and *at* the emotions of the others. But sometimes the artist may lead the reader or spectator to feel emotion *at* even the principal character. This is indeed the very point of Flaubert's "Madame Bovary," as Lubbock so penetratingly shows. Flaubert keeps muttering to his reader, so to speak, "Look at her! See how she acts! What a silly woman!" An extreme appearance of objectivity is obtained by this treatment of emotion.

Sometimes feeling *at* and feeling *with* are combined. Painting particularly lends itself to such a combination, because being a spatial art emotions may overlay one another within the

work and be separately and successively felt. I have in mind a picture of Daumier's representing a woman and a child with a basket of clothes climbing the steps of an embankment of the Seine. It is painted in somber browns and cream. The figures are modeled in heavy simple masses, and the bright apartment houses across the river glare in contrast with the murky shadows through which the figures are moving. A dull sense of sadness first emerges from the painting, then pity, and then indignation. There is no doubt that these layers of emotion were intended by the artist and lie within the picture. It is a picture with a definite social comment, something profounder than irony because of the very richness and variety of emotions underlying the irony. Furthermore, these different emotions at once intrude upon and restrain one another, so that we feel the event deeply and yet do not take the picture as a piece of propaganda or begin to think about practical action. On the contrary, the social conflict suggested becomes itself a factor of enhancement fusing with the contrasts of color and line and mass. And at the same time (art is so full of paradoxes) the

full realization of this event because of its restraint and because of its very intrinsic beauty acts in the long run as more powerful propaganda than propaganda.

If, then, emotion, as we have described it, is so important in art, why do artists so often disparage it? Why is an emotional appreciation so often regarded as weak and superficial? Because the objectionable gushing emotion is often not an emotion in the work of art, or at least not the full realization of the work of art. Because the emotion is false to the work of art, and in that sense a false emotion. Because, in one word, it is sentimentality.

James's often quoted anecdote of the old couple before Titian's "Assumption" exemplifies the reason: "I remember seeing an English couple sit for more than an hour on a piercing February day in the Academy at Venice before the celebrated 'Assumption' by Titian; and when I, after being chased from room to room by the cold, concluded to get into the sunshine as fast as possible and let the pictures go, but before leaving drew reverently near to them to learn with what superior forms of susceptibility they

might be endowed, all I overheard was the woman's voice murmuring: 'What a *deprecatory* expression her face wears! What *self-abnegation!* How *unworthy* she feels of the honor she is receiving!' Their honest hearts had been kept warm all this time by a glow of spurious sentiment that would have fairly made old Titian sick" (Psych. vol. ii, pp. 471–2). There is, to be sure, a touch of this emotion integral to the picture, but the old couple taking this touch as their cue went off into far distant events on an emotional spree of their own. Their enjoyment was, of course, æsthetic of a kind, but not of Titian's kind nor approximating the depth and breadth of Titian's kind. In a word, they did not understand the picture, and the artist naturally resents it—the more so as he is generally justified in believing that his work of art is a basis for a richer experience than their spontaneous gushes.

If it is an orgy of blind emotion that is wanted, the bones of a saint, a blessed biscuit, or two sticks crosswise would do as well. To the same tenor, James remarks in the very sentence after the foregoing quotation that "Mr. Ruskin some-

where makes the (for him terrible) admission
that religious people as a rule care little for
pictures, and that when they do care for them
they generally prefer the worst ones to the best."
It is, moreover, a point made by the modern
Irish mystics, that if one is a saint he is not a
poet. Mystic absorption may be the summit of
realization; but it is beyond art, and as the
mystics themselves aver, it is ineffable. Our
problem here is not to estimate the æsthetic
value of a mystic experience, or of any blind
emotional experience. The value may be very
high. But we can with assurance state that a
person who wanders with his thoughts or his
images or his emotions away from the work of
art he is contemplating, is not realizing the event
there presented, and we are free to suspect that
he lacks the cultivation to do so.

Much has been written about the æsthetic
emotion. There is no specifically æsthetic emo-
tion, but from the discussion into which we have
been led, it is clear that there is a distinction
between what may be called an artistic and an
unartistic emotion. The one rises out of and
is the direct fusion of the details of the work

of art. If momentarily a complete fusion occurs
—what Dewey calls a seizure, which is a sort
of ecstasy of appreciation—diffusion will follow
and let one down into the discriminated details
of the very work of art. But an unartistic emo-
tion is one set off possibly by a work of art,
but based upon conflicts not integral to the work.
It may lead off into practical action, or it may
be more or less objectless in the sense that it
is undirected and uncontrolled. I see no reason
why an objectless emotion might not through its
intensity of quality have considerable beauty.
It is likely, however, to lack the spread of quality
which a discriminable structure lends to a work
of art.

A certain balance of emotional fusion and
analytic discrimination is the normal æsthetic
experience. A man who habitually flies off into
emotional ecstasy in the presence of a work of
art is likely to lack depth of appreciation, even
if the emotion is relevant. But it is better to do
this than drift into the opposite habit of con-
sidering a work of art only in a cold, analytic
way. This hard-boiled attitude is very discon-
certing to a novice who is eager to appreciate,

and full of potential enthusiasm. The calm technical judgments of a connoisseur, especially when flavored with sarcastic innuendoes about callow ebullitions, is stifling to emotion and the young man becomes afraid to enter into the work he wants to appreciate. He begins insincerely to emulate the manner of the expert, and to imitate his witticisms. Actually, if he but knew it, his natural effusions, thin as they may be, are closer to a realization of the work, than the erudite comments of such an expert.

For a description of the frigidity of the jaded critic, from whom all warmth of appreciation and sense of beauty has vanished and has been displaced by a mechanical clicking of habitual judgments, I turn again to James: "Where long familiarity with a certain class of effects, even æsthetic ones, has blunted mere emotional excitability as much as it has sharpened taste and judgment, we do get the intellectual emotion, if such it can be called, pure and undefiled. And the dryness of it, the paleness, the absence of all glow, as it may exist in a thoroughly expert critic's mind, not only shows us what an altogether different thing it is from the 'coarser'

emotions we considered first, but makes us suspect that almost the entire difference lies in the fact that the bodily sounding-board vibrating in the one case, is in the other mute. 'Not so very bad,' is, in a person of consummate taste, apt to be the highest limit of approving criticism. 'Rien ne me choque' is said to Chopin's superlative praise of new music. A sentimental layman would feel, and ought to feel, horrified on being admitted to such a critic's mind to see how cold, how thin, how void of human significance, are the motives for favor and disfavor that there prevail. The capacity to make a nice spot on the wall will outweigh a picture's whole content; a foolish trick of words will preserve a poem; an utterly meaningless fitness of sequence in one musical composition set at naught any amount of 'expressiveness' in another" (Psych. vol. ii, p. 471).

Better to remain like the old couple before Titian's "Assumption" than become like this. It is the balance between these opposites that gives real good taste, and makes the genuine expert. Not that we can always appreciate a work of art at this balance. We slip back and forth from

a more emotional to a more analytical attitude towards the work before us. The realization of the work is increased by these changing attitudes. But if we have lost the capacity for 'seizure,' for rich emotional fusion and ecstasy in a work, we have lost something precious. We have lost the power of full realization. We cannot be too far emotionally carried away by a work of art, as long as the emotion is the relevant emotion, that actual fusion of all the strands of that individual event.

Emotion is the culmination of vitality in art, of those factors which strip away habit and reveal the quality of the event. It is also the beginning of organization. It is not only a factor for increasing the intensity of quality, but also for enlarging its spread. The two chief methods of organization through emotion may be called the principle of dominant emotion, and that of natural emotional sequence.

The principle of dominant emotion is very simple. We noticed earlier the connection of emotions with action patterns. The elements of these patterns become then stimuli for specific emotions, which acquire individualities of their

own. Furthermore, alternative stimuli develop. There are not only sad tones, but sad combinations of colors and lines, and sad words, and sad rhythms. The emotion of sadness has a specific individuality, but with many alternative strands. And all these strands or stimuli are schematically organized in that they constitute interlocking action patterns specific to that emotion. Now, the principle of dominant emotion is the selection, for a single work of art or section of a work, of stimuli belonging to one emotional scheme of action patterns. The specific quality of that emotion will then be echoed and reechoed through all parts of the work; and all details, diverse in other respects as they may be, become organized and unified through the simple emotion evoked by them. Furthermore, the expressive power of each detail becomes intensified by the repeated evoking of the same emotion. The principle is too well known to need exemplification.

But the principle of natural emotional sequence is not so well known. In our commerce with our environment, we find ourselves confronted by situations which call out regular se-

quences of emotions. A man meets a stranger in a lonely spot, or he is caught in the rain, or his boat capsizes, or he is handed bad news, or he sees a friend after long absence, or he finds a rival with his girl. There is a somewhat limited sequence of actions with corresponding emotions which we expect a man to follow under each of these circumstances. One of these normal sequences of emotion, I call a natural emotional sequence. A literary or dramatic narrative following one of these sequences is obviously unified to a high degree by the organization of action and emotion involved in such an anticipated sequence. Here is a very short and powerful instance of such emotional organization:

THE REAR GUARD*

By Siegfried Sassoon

Groping along the tunnel, step by step,
He winked his prying torch with patching glare
From side to side, and sniffed the unwholesome air.
Tins, boxes, bottles, shapes too vague to know,
A mirror smashed, the mattress from a bed;
And he exploring fifty feet below
The rosy gloom of battle overhead.

*Reprinted by permission of the author.

Tripping, he grabbed the wall; saw someone lie
Humped at his feet, half-hidden by a rug,
And stooped to give the sleeper's arm a tug.
"I'm looking for headquarters." No reply.
"God blast your neck!" (For days he'd had no sleep.)
"Get up and guide me through this stinking place."
Savage, he kicked a soft, unanswering heap,
And flashed his beam across the livid face
Terribly glaring up, whose eyes yet wore
Agony dying hard ten days before;
And fists of fingers clutched a blackening wound.
Alone he staggered on until he found
Dawn's ghost that filtered down a shafted stair
To the dazed, muttering creatures underground
Who hear the boom of shells in muffled sound.
At last, with sweat of horror in his hair,
He climbed through darkness to the twilight air,
Unloading hell behind him, step by step.

In this instance the physical circumstances which account for the sequence of the emotions are described step by step. But the principle becomes particularly interesting when there is a separation between the description of the circumstances and the sequence of the emotions, as in program music; or where there is no description of circumstances, but only the sequence of emotions. The sense of rightness or inevitability of emotional sequence in much pure

music, especially when it is of a rather dramatic type like Beethoven's, is due to the sequence being a natural one such as would accompany a physical situation, but without the situation. The unity is then just as firm, and much more subtle, than in the case of the poem quoted. Something closely approximating such pure emotional sequence occurs frequently in poetry, as in Keat's "Ode to a Nightingale," or Shelley's "Adonais." Changing circumstances are hinted at, but for the most part the emotions are nearly as disembodied from their physical accompaniments as in pure music.

Emotions are also organized by the regular design principles of contrast and gradation. But in these rôles the emotions are not active principles of organization but passive materials organized. So, here is the time to turn our thoughts definitely towards matters of organization.

Chapter V

FUNDED INTERESTS, SCHEMES, AND SCALES, EXTRINSIC MODES OF ORGANIZATION

QUALITY is the life of art, organization the body.

We have seen how one of the great paradoxes of art operates, how conflict, which is the source of practical action, and is one of the principal means of draining an event of quality can nevertheless be so controlled and utilized as to become the chief means of intensifying quality. We are now to examine a second paradox. We are to see how analysis, which is, so to speak, the inside of organization, and which is normally another means of draining an event of quality, can nevertheless also be made to increase quality, not however by enhancing its vividness, but by giving it spread and depth. And to pile paradox on paradox, not only are analysis and conflict each of them intrinsically antagonistic to quality,

but they are also intrinsically antagonistic to each other. For the practical significance of analysis is to dissolve conflict, and organization is nearly synonymous with harmony. Yet the organization wanted in art is one that produces harmony without dissolving conflict. This is literally the case, and the preceding sentence may be taken as a general maxim for æsthetic organization.

For organization without internal vitality, and for the most part that means without internal conflicts, is the substance of academism. The reason that academism is always subsequent to a vital period of art, is simply that analysis is not the essence of beauty while quality is. A specific art form is generated out of the demands of qualities to be organized, but, when the form is abstracted from its qualities, and produced in calm sterility of thought and intellectual deliberation, then we have academism. An academic work is not so much bad, as just not very beautiful. When we say a work is 'bad,' putting some energy into the term, we mean that the work has some vitality and has stirred us and then shocked us into criticism and practical

resentment. An academic work is just uninspiring and barren. Its calm and harmony are its curse. For the harmony that is beauty is a harmony of conflicts. A great work of art is an organization of intense qualities, and (except rarely) intense quality cannot be achieved without conflict. So, this is the reason for all our paradoxes. There is quality without conflict, but not often vivid quality. There is beauty without organization, but not massive beauty. So, for a work of great beauty we must have a massive organization of conflicts.

The sources of organization are many. For our purposes of a general survey, we may divide them into three on the basis of whether or not the elements of the organization live fully in the work of art, or are drawn in from the environment, or are half one and half the other. The first type of organization I shall call intrinsic, the second extrinsic, and the third intrinsic-extrinsic. I wish to proceed in exposition from the outside in, and accordingly will begin with extrinsic organization, of which there are two kinds, funded social interests and schemes.

It has frequently been observed that the art

of a period reflects in a rather high degree the social conditions of that period, and that when an artist tries to cut loose from his social environment his art becomes imitative and weak. From our earlier discussions, the reason for this essential connection is obvious. A work of art is not an isolated thing. It is a creation by a man who himself is largely a creation of his society. We have used the term, patterns of action, and have noticed the service of patterns of action as carriers of emotion. Their importance for the analysis of behavior can scarcely be exaggerated. They are, of course, fundamentally organizations of strands, and a man's character or personality is the aggregation or organization of these organizations of strands. This is simply the contextualistic way of saying that a man's character is the sum of his interests. But an interest is not something static and insulated. It is something that enters into a man out of his environment, and something which he in turn projects again back into the environment. Or rather, it is something centered indeed in a man, but embedded in his social and physical environment. It follows that

those interests are richest which reach furthest into the environment. And it follows again that a work of art that draws upon the richest interests will, other things being equal, be the richest work of art.

Now, interests change from epoch to epoch. Men today are not greatly excited over religion, and they are not in the least exercised over the divine right of kings. The deeds and the misdeeds of priests and princes and the doctrinal and political issues of church and kingdom, which could so absorb a Dante, a Rabelais, or a Milton, each incidentally in his particular way depending on his particular epoch and geographical location, come rather flat to us. But not so flat as if a modern writer tried to produce a *Divine Comedy,* a *Gargantua,* or a *Paradise Lost.* These books live, as we say, in part on account of the deep interest these writers had in their subjects, so that we catch the contagion of their interests. Epochs erupted through these men, who were the craters of their times, and we look in amazement at their great natural outbursts though far from the flowing lava and almost out of range of the volcanic dust. A

modern writer, with all the ability in the world, cannot put himself in another age and erupt there. And what is more to our present point, he cannot even so identify himself with the social forms of the time as to make them into a strong organizing frame for his work of art. There is something essentially weak in the historical play or novel, *unless* a past epoch is simply used as dress and scenery for depicting the social forms of a present epoch, in the manner, for instance, of the Elizabethan drama; but then the play or novel is historical only in name and decoration.

These illustrations show by contrast how it is that social interests find their way into works of art, and why it is that only contemporary interests have a strong and spontaneous organizing power.

But what specifically are these organizing social interests? They are fashions, manners, laws, forms of government, customs, mores, instinctive modes of behavior. There is obviously a sequential order in this list, of which more presently. But first we note that these social forms are all from the æsthetic point of view

extrinsic. They all function and exist quite independently of any works of art. Their origin is outside art, and, if there were no art, they would still continue to function without let. Furthermore (what renders them fully extrinsic) they are never completely incorporated within a work of art. Rather a work of art participates in them in the literal sense of entering partly but not wholly into them. A novel like *Vanity Fair* assumes the social organization of England contemporaneous with Thackeray. That whole organization, however, from the fashions of the day to the deep lying impulses of sex and self interest, was not fully depicted in the novel; it was only tapped. How much it was tapped, moreover, is something that can never be precisely determined, because what is explicitly described in the pages is but a shadow of what is intentionally suggested. But it would be ridiculous to maintain that, because so many interests were suggested, all the social interests of England were suggested. Such is the intricacy and extent of the organization of social interests, that it can never be reasonably said that the whole organization is incorporated in

a work of art. As a total organization, it is extrinsic to the work. And yet the total organization is assumed in the sense that the interests actually depicted and suggested in the work of art know their place in the whole.

The organizing power of these interests in a work of art is derived not primarily from the interests actually present or suggested in the work, but from the sense of the total organization and the place of these interests in that organization. When Thackeray tells us that George Osborne is an officer in the English army and describes his activities in that capacity, the organization obtained for the book is not simply that of the described and suggested events but rather that of the place of an officer in the English army, the relation of the army to other departments of the government, and so on, as a result of which we are not surprised to find him in Belgium when Napoleon's army is approaching, and we understand his death in terms of the plain duty of a soldier. The whole organization of the English army does not appear in the book, but the place of George Osborne in that organization does appear, and in that sense

the organization of the army functions as an organizing instrument in the book. It functions extrinsically.

I gave the list of social structures above in a sequential order running from fashions to instincts. The basis of the order is obviously the epochal and geographical spread of the structures. A fashion lasts only a few years and is restricted to a relatively small area of the globe. A human instinct and its basic action pattern is as old as man and as extensive as the range man inhabits. Yet both the fashion and the instinct are equally social structures and constitute a framework which can be tapped by a work of art and within which specific actions can have a place and find their relations to other specific actions which also have a place. Through this framework extrinsic to the work of art, the specific actions are organized nevertheless within the work. But the difference of spread between two such social structures is obviously of considerable æsthetic importance. For it means that a work of art which for the most part taps only a fashion cannot have a very long or wide appeal. Yet in a locality and for the brief life

of the fashion, the strength of the structure may be as great as that of an instinct. Certainly, patriotism, for one example, is as strong at some times in some localities as sex, and yet it is little more than a fashion. It is consequently easy for an artist to mistake or even purposely to substitute intensity for depth, so that a certain amount of possibly rather good art is fugitive just because it is only an art of fashion.

It does not follow, however, that any work of art that taps fashion is fugitive. For fashions often ride on manners, which ride on customs, which ride on instincts. When such a superimposed system is tapped, then the custom described is simply a particular cultural mode of appearance of an instinct, and the manner the national appearance of the custom, and the fashion the provincial appearance of the manner. In this way each level derives dignity from the one below it, and a fashion is no longer fugitive but is the representative for the moment of an instinct and everything between. The range and depth of appeal of an artist, therefore, depends not on his avoiding the more fugitive social structures, but simply on his tapping the more

extensive ones, after which he may tap as fugi-
tive structures as he pleases so long as he ties
these in with the extensive ones. And, paradox-
ically, the more of these fugitive structures he
then ties in, the richer and the more appealing
his work. Fashions in this way acquire a
vicarious permanence through art. One can
scarcely think of a Madonna except in the latest
fashions of fifteenth century Italy!

These social structures, or organizations of
interest, then, are the source of one species of
extrinsic organization in art. The frames of
these structures are not clean cut. They overlap,
and interpenetrate and permeate one another to
such a degree that there is no stating where one
structure ends and another begins. Moreover,
they are so concretely the interconnections of
interests themselves that the opposition we fore-
told between quality and relation, or between the
immediate and the analytic, hardly comes to the
surface here.

In both these respects, the second species of
extrinsic organization, schemes and scales, is in
marked contrast to the first. The frames of this
second species are very clean cut and precise,

and their elements are so abstract and relational that it is sometimes hard to believe that they are embedded anywhere in the texture of existence. Fundamentally, however, they are probably of much the same nature as social structures and are tapped or participated in by individual events in much the same way. That is to say, they are organizations of events. And in some instances the difference between the two kinds of extrinsic organization cannot be insisted on. A musical mode, for instance, might just as fitly be called a social structure as a scale. But we treat it as a scale.

Schemes are systematic summaries of discriminations. And scales are selections of elements out of schemes according to some rule. The gamut of pitches from the lowest discriminable pitch through the sequence of all discriminable pitches to the highest, is a scheme. A selection from this gamut of a certain succession of pitches according to a rule which gives us our major scale, is a scale. A whole pianoforte keyboard very roughly represents the scheme of the gamut of pitches: while the white notes alone, representing successive octaves of the

key of C major, are a scale. Here we can see visually that a scale is a definite selection of the total number of pitches in the scheme, since the black notes are left out. As a matter of fact, of course, many other pitches of the scheme of pitches are left out, because there are many discriminable pitches between the notes of a pianoforte keyboard and also many extending off each end, so to speak.

The organizing power of a scheme or scale is clear at a glance. It furnishes a structural frame for the elements of a work of art, so that these elements are not isolated particles tossed together, but are interconnected and placed in reference to one another. A little melody of three or four notes is much more than a combination of three or four notes. It is a spacing of these notes by reference to the scheme from which they come. And not only is the interval between each two notes felt but the relations of these intervals to each other are felt also and form a compact structure. In exactly the same way a certain arrangement of four dots is not just a combination of four dots; it is a diamond. The intervals between the dots perceived in

reference to a field of locations create a compact structure, in which each dot reaches across the field to every other dot and clamps them with invisible braces.

It is clear also why these schemes are extrinsic. The little melody of four notes does not incorporate the whole gamut of pitches. It merely participates in the structure of the scheme, and the scheme lies largely outside of the melody. So also, the field of locations, in which the diamond participates, extends far and wide beyond the points occupied by the diamond. And yet, exactly as with the social structures which are extrinsic after the same manner, the whole frame is involved or referred to in any form that participates in it. In some sense, the whole gamut of pitches functions in the little melody of three or four notes in order that the melody may have its form. Yet, of course, all the pitches of the gamut of pitches are not present nor even as sensuous pitches represented. The specific structure of the melody depends on their not being represented. It is precisely because the melody consists of only three or four notes that it has a peculiar structure and an individuality

of its own. In short, the individuality of the melody depends upon two apparently opposed factors. It depends on the fact that the melody is a selection of *only* three or four notes, and it depends on the fact that the structure of the whole gamut of notes is present in the selection. What is left out is the sensuous presence of all the other notes.

The circumstance which makes this paradox possible is that notes are not insulated entities but are systems of strands, and it is the references of these strands embedded in the qualities of the notes themselves that constitute the presence of the scheme of pitches in the melody. These references must, moreover, be definitely sensed, or else the melody disappears. That is to say, unless sufficient analysis is there present, unless sufficient attention is given to the relations involved in the notes, there is no structure and no melody, but only notes. What, therefore, explains the paradox of the participation of sensuous elements in a scheme, is the very thing that thrusts into prominence the paradox of the æsthetic value of analysis.

Let me repeat, it requires analysis to be aware

of an extrinsic scheme. The attention must play upon the references in notes to a sufficient degree for the scheme, in which the notes participate, to endow the notes with its structure. Yet this attention upon the outward references of the notes is the very process which tends to drain the notes of quality. When a person is intent on analyzing the chords and sequences of a musical composition, he is not intuiting the qualities of the piece. His appreciation is drained off in intellectual exercise. Nevertheless, only in proportion as a person is aware of the relations involved in the chords and sequences of a piece, is he aware of the structure or able to appreciate the full quality of the piece. The æsthetic value of the piece depends on a balance of analysis and quality. And the balance here is exactly analogous to that which we find in discussing conflict. As with conflict, so here, the aim of the artist is to inject as much of the hostile element into his work as he can without losing the quality of his work. But in this case his intention is not to increase intensity of quality but to gain massiveness and spread of quality.

Of course, in making these remarks I do not mean that in actual appreciation a tagging and pigeon-holing analysis goes on in the mind of the competent listener: here is a dominant seventh, and here a dissonance of the ninth, here a modulation to the relative minor, and here an ending on the authentic cadence. This is explicit disruptive analysis. But I do mean that this very analysis rendered potential as strands implicit and fused in the heard texture of the piece is the basis for the structural appreciation of the piece and for that extensive spread of quality we find in what we call our greatest music. But even from this it does not follow that a person who cannot feel all these relations implicit in a piece, cannot appreciate it. All I say is that he cannot fully appreciate it. And for such a person's comfort I may add that he may be æsthetically better off than some technical musicians who have full powers of analysis but have lost the æsthetic power of fusion.

And now to give some idea of the range of application of these extrinsic structures, I shall list and briefly comment upon a few of the most important schemes and scales that appear in art.

MODES OF ORGANIZATION

To begin with auditory schemes and scales, since we have already mentioned them. There are two discriminanda schemes here: one of auditory intensities and one of pitches. Since every pitch has potentially every discriminable intensity from the softest to the loudest, and since both of these schemes are one dimensional, they can easily be combined into a single two dimensional scheme. We can visualize the pitches as going from left to right and the intensities from below to above. We thus establish a two dimensional system of points or pegs of reference with regard to which any sound may find its schematic relations with other sounds.

It is worth noting that this scheme of human auditory discriminables is embedded, by means of correlations, in a physical scheme of frequencies and amplitudes of air vibrations. Thus the auditory scheme of pitches is correlated with the physical scheme of air vibrations running from about 16 vibrations per second up to about 20,000. The physical scheme is the scheme for the environmental control of sounds, and as such does not æsthetically concern us. But in another way it is of æsthetic interest, since it

indicates the possibility of sounds we do not hear, sounds correlated with vibrations of greater or less frequency than fall within the scheme of humanly discriminable sounds. There is evidence that some animals hear these sounds. The scheme of human sounds, therefore, is only a selection from the scheme of all possible sounds.

Then within the scheme of human sounds are other selections constituting scales. The construction of these scales is uniformly a selection of a small number of tones within an interval known as the octave. In other words, the gamut of pitches is first divided up into octaves and then a selection of pitches is made within an octave, and this selection repeated within each octave through the whole gamut. The selection of pitches constituting a scale is therefore relative not absolute. If, for example, the lowest pitch selected is that correlated with 16 air vibrations per second, the next octave pitch will be empirically found to have 32 vibrations per second and the next 64 and so on—always the frequency of the upper pitch being twice that of the lower. But if the lowest tone selected

were 18, then the next would be 36, and the next 72, and so on. This relative selection of scales out of the absolute gamut of pitches has an important bearing on the nature of musical structure in what is called key relationships. In other words, a relative structure of keys is embedded in the absolute structure of the gamut of discriminable pitches. A great structural richness is obtained thereby in music. For when a number of intervals are played, we discriminate not only their relative positions in the key or scale, but also to a certain degree their absolute positions in the gamut of discriminable sounds. We know not only that this is a tonic triad, but that it is a tonic triad at high or low or middle register.

Moreover, once a scale is selected, it generates a system of internal relationships largely summarized in the term, tonality, and these in turn are reflected in a work of art — but to enter into these relationships would be to write a chapter on harmony.

Turning now to time, we find that there are three schemes of temporal elements. First, the scheme of temporal locations which we may

visualize as a calendar. This is a one dimensional scheme extending from an indeterminate past into an indeterminate future. In practice a selection of times or dates is always taken out of this scheme of temporal locations, and we may call the selection a history. The relation of a history to the total scheme of temporal locations is much like that of a scale to the total scheme of pitches. This scheme with its histories functions prominently in the novel and the drama, but also to some extent in music and dance, and even in painting and sculpture. It may also function prominently in architecture or in any work of art where the sense of epoch is deeply involved.

The second and third temporal schemes are the gamut of tempos (slow to fast) and the gamut of durations (short to long). These two gamuts interplay in concrete textures and make up between them much of what we call the structures of rhythms.

There are five important spatial schemes. First the scheme of spatial locations. For the purpose of art (since the perceptions of art do not become involved in Einsteinian problems) this is a three dimensional scheme of height,

width, and depth. It is used in architecture and sculpture and painting, in the novel and the drama, in dancing, and even slightly sometimes in music. But it is rarely, if ever, used in any of these arts except through a projection or a perspective. A projection is to the total scheme of spatial locations what a history is to the scheme of temporal locations, but with an added complication in that a projection is not only a selection but a distortion (that is, a more or less systematic dislocation) of the locations of the mother scheme. The variety of these projections can be appreciated by studying the history of painting. They are the conventions of spatial representation, and range all the way from our customary conical projection (incidentally by no means as logically carried out by our classic painters as we are apt to assume) to the highly arbitrary spatial representations of the Egyptians. These are all æsthetically legitimate so long as we can read them off fluently, so long, that is, as the analysis of them can be rendered implicit and be fused in the quality of a texture.

Of course, such projections are involved in all human vision. When I look down the nave of a

cathedral, the absolute scheme of spatial locations is functioning there in my successive appreciative textures and is binding these textures into a unity that would otherwise be sorely missed. I sense that now I am viewing the nave from under the west wall and now from the center and now backwards from the transept. These locations order my successive perceptions and synthesize them. But each perception nonetheless is a projection and probably a rather illogical one, and the distortions of these projections enter into the total experienced texture and tincture its quality with the qualities of their peculiar forms. Moreover, the architects and sculptors of the building were counting on the effects of these projections for the specific qualities or subtleties of their composition. As in music we hear tones in scales which are themselves in the scheme of pitches; so in architecture we see buildings in projections which themselves are related to a scheme of locations: and the richness of the structure of the work depends in both cases on the interrelationships of these extrinsic structures to each other.

Three of the remaining spatial schemes have

to do with lines, and one with masses. The three linear schemes are a gamut of lengths, a scheme of attitudes, and a scheme of curvatures. These schemes are only indirectly related to the scheme of spatial locations, and are better regarded as quite separate schemes. A line is, to be sure, always located, and so are discriminated points in a line; but the sensuous quality of a line is not due primarily to its location in the scheme of spatial locations, but to its place in the three linear schemes just named. The sensuous effect of the taut curves of a Gothic arch, for instance, is the same for each successive arch down the nave, and this effect is definitely distinguishable from that of the succession of arches in their spatial locations along the length of the nave. The effect of the curves is due to the curves themselves and the feeling that they might have been rounder or straighter but were so thoughtfully selected to be just the tautness they are. Their effect, in other words, is due to their place in the gamut of curves. But the effect of the succession of arches is due to the location of these in the total three dimensional frame of the cathedral and the particular projection of the point of

view. A line in art is more than a succession of locations or points, geometers to the contrary notwithstanding. Like color, it always involves locations, but no arrangement of locations is equivalent to the quality of a line.

The gamut of lengths from short to long needs no explanation. A long line is sensuously different in quality from a short one, and is in no æsthetic sense whatever a multiplication or extension of a short line. It is an interesting relational fact, which comes out in reflecting upon the gamut of lines, that some lines are a half or a quarter or a third the length of others. It is an æsthetic fact of just the same sort as that of interval relations among pitches. And as these interval relations in the gamut of pitches generate octaves and double octaves and fifths, so these relations of linear lengths generate squares and two-to-one and three-to-one rectangles, and triangles and crosses and figures of all sorts with linear relations simple or subtle. These relations can be named in terms of centimeters and inches, just as musical pitches can be named in terms of wave frequencies. But the sensuous quality of a length is as different from its inches as the sen-

suous quality of a musical pitch from its wave frequency.

The gamut of lengths is a one dimensional gamut like that of musical pitches or intensities. At one end is the shortest discriminable line, at the other the longest. The longest line is, of course, not of infinite length. It is the longest line the eye can take in at one sweep, for, once more, the lines in the gamut of lines are not geometers' locational lines, but artists' sensuous lines.

The second linear gamut is that of attitudes, whether a line is vertical, horizontal, or oblique, and, if oblique, at what angle of obliquity. To a geometer these attitudes are indifferent, and a rectangle on its side has the same properties as a rectangle on end. To an artist, however, the two rectangles are different organisms. The one has predominant horizontals and the other predominant verticals, and the æsthetic characters of the two are not at all the same. A square balancing on a corner is æsthetically very different from a square resting on its side. These differences are due mainly to differences of linear attitudes.

The scheme of attitudes is a circle. If we start with the vertical, we can then pass through the right obliques of say 80°, 60°, 45°, 30°, 10° pitch and thence to the horizontal. Then we pass into the left obliques of 10°, 30°, 45°, 60°, and 80° pitch, and thence to the vertical again. This circle, thus, represents all possible attitudes, and is the scheme of these attitudes.

Our means for judging the relationships of curves is more obscure than that for judging straight lines. The scheme for circular curves can be easily made out. We have a gamut of circles from small to large, and a gamut of segments of curvature for each size of circle. Any particular circular curve we judge as such a segment of such a sized circle. But to this scheme must be added our means of judging the relationships of spirals, and ovals, and the like. We sense these relationships, I think, by judging the degree of alteration of these curves from the nearest circular curve, and for the rest assisting ourselves by recourse to the scheme of locations, which keeps the track of the curve from getting lost (though not always from getting confused). One must not think, however, that because the

basis for the scheme of curvatures seems to be a scheme of circles and segments of circles, therefore circular curves are æsthetically best. They are in general, as Ruskin so persistently reiterates, the least interesting.

By mass I mean a sense of filled extensity. The sense of mass is not separable from an area or volume of locations. But the sense of a *filled* area or volume is not a *mere* sense of area or volume. The empty spaces of a cathedral have volume but no mass, while any one of the piers has mass. Mass, I think, is not, strictly speaking, dimensional. It gets its dimensions from the scheme of spatial locations. Masses are large or small and that is schematically the end of it.

Color is the only visual means of discriminating mass. It is areas of color that furnish a visual filling of space. Yet colors are not schematically spatial. We do not speak of large and small colors, but only of large or small areas of color. The schematic properties of color are three: hue, value, and saturation. The discriminanda scheme of hues makes a circle — red, orange, yellow, green, blue, violet, purple, and back to red. The scheme of values makes a line

from black at one end through the grays to white at the other end. The scheme of saturations for any hue is also a line from gray at one end to the given hue at the other. These three schemes can (and for the full sense of the relationships of colors, must) be brought together into a single three dimensional scheme of colors known as the color cone. This has the scheme of values (the grays) for its axis, the scheme of hues for its periphery, and the saturations for its internal filling. The relations of colors are determined by their place in this color cone. Without these schematic relationships, we should not know what is meant by contrast or gradation of colors, and there would be no sense in speaking about organizations of color.

It is possible to make selections of colors out of the color cone in accordance with rules. These selections are called scales or palettes, and are related to the color cone as musical scales are related to the gamut of pitches. But color scales are, for a number of reasons, of not nearly so much importance as musical scales. Even when artists employ them, spectators are likely to be

unaware of them and miss little or nothing by their ignorance.

These schemes and scales mentioned are by no means all there are, or even all that are frequently employed in art. There are schemes for smell, and taste, and touch, and even additional schemes for hearing and sight (such as a scheme of angles), which are not reducible to the schemes we have described. But those we have described are sufficient to demonstrate the enormous importance of schemes as instruments of organization in art.

TYPES, OR INTRINSIC–EXTRINSIC
MODES OF ORGANIZATION

THERE is no hard line between types and extrinsic modes of organization. But there is a definite æsthetic difference of form in the case where a work of art achieves organization by participating in a structure largely external to it, and in the case where it fully or almost fully incorporates a ready-made structure within it. In the one case the organization is achieved by the work of art's finding its place in an external structure; in the other, the external structure is swallowed up in the work of art.

Compare, for instance, a stereotyped musical form like the sonata form with the gamut of pitches. Both modes of organization are extrinsic to a work of art in one respect: namely, neither of them owes its existence to any one work of art; if any single work of art organized by them should be entirely destroyed, neither of

these forms would in any way suffer from the destruction. But in another respect the two modes of organization are very different. No single musical composition involves the whole scheme of pitches, but only makes selections from them. Moreover, the arrangement of pitches in the scheme is not bodily imported into the work of art. The schematic organization of a piece of music does not consist in sliding up or down the gamut of pitches, but only in precisely determining the relations of any selected pitch with all others. In this latter respect, the type organization of sonata form is of an exactly opposite sort. Any single work of art adequately organized by this form does bodily incorporate the whole, or nearly the whole form, and the arrangement of the features of the form is imported faithfully into the work. Extrinsic as regards the mode of organization, intrinsic as regards its embodiment in a work of art—this is the characteristic of type.

The organizing power of a type is more evident than that of any other mode of æsthetic organization. In so far as a work of art is structured by a type, the labor of organization is all

done before the artist begins to compose. When a piece of music is written in sonata form or a poem in sonnet form, the structural skeleton of the work is given in advance. Neither the artist nor the appreciator has to think any more about that. There is no labor of selection as in the use of purely extrinsic modes of organization, no labor of creation as in the use of purely intrinsic modes of organization. The organization is both wholly incorporated in the work of art, and ready made.

There is, furthermore, nothing that so securely guarantees organization as type. An artist takes a risk when he selects elements out of an extrinsic structure; he takes an even greater risk when he creates his own intrinsic structure. But when he engages a type to perform the service of organization, he so far absolves himself from all further responsibility. A poem correctly written in sonnet form is well organized whatever else one may say about it. And if a reader does not happen to know what the sonnet form is and thereby fails to perceive the rich texture of its form, it is the reader who appears ridiculous and not the writer.

For these reasons, the bulk of æsthetic criticism is directly or indirectly concerned with types. The critic even more than the artist can feel at ease and secure here. Erudition has legitimate free play here. Whether a poem has vitality or not, is a judgment requiring sensitiveness and taste and caution, for so far as no similar judgment has been made in the past, it is an exploration into a new territory, since unless the territory is new the poem definitely fails of vitality. But whether or not a poem is a correct sonnet is a judgment which requires only learning and attention, and which, moreover, may be asserted with assurance and an array of evidence.

Then, can there be any great æsthetic value in types, if they are so easy and so secure? Or, in other words, would not an artist do better to employ only extrinsic and intrinsic modes of organization and so far as possible to avoid types? This question might be very hard to answer but for a unique value which types alone introduce into art. This value is that of recognition. There is a specific delight and glow in the recognition of something familiar, which has been

felt to have æsthetic significance since the days of Plato and Aristotle. This glow of familiarity is itself a quality—the quality, in fact, of the type recognized. The truth of this observation comes out clearly as soon as we ask for the conditions which increase the intensity of this glow. They consist mainly in the rarity and unexpectedness of the fulfilment of the type, and we recall that novelty and conflict (for rarity and unexpectedness are aspects of novelty and conflict) are the chief sources of quality. It is not the person you meet regularly on your customary daily routes who stimulates your most vivid sense of recognition, but your chum of years past whom you believed miles away and who cuts across your daily habits. We infer that an artist will probably tend to seek out types which have these properties of rarity and unexpectedness, so that in addition to the mere organizing power types possess, which might be rather dull, they will have that vivid glow of recognition, which illuminates the very quality of the type itself. How this latter end is attained we shall discover presently.

But first, what precisely is a type? It is a sys-

tem of strands that fully (or almost fully) appears in an individual object and is repeatable in other individual objects. By fully appearing in an individual object, we mean the intrinsic character of a type. By repeatability we mean its extrinsic character. What remains to be explained is the meaning of system. By system is meant that the references of the strands constituting the type mutually involve each other and do not run off at loose ends. The difference between a system of references and loose references is roughly the same as that between the controlled associations in thinking, let us say, about the concept of a Petrarchan sonnet (sonnet — fourteen lines — sestet — octet — abbaabba rhyme scheme — etc.) and the uncontrolled string of associations in languid musing (sonnet — Keats — Rome — Coliseum — gladiators — prize fighting — Dempsey). In the first case, all the associations mutually refer to each other, and it makes no difference with which strand you start, sooner or later all the other strands will come in. Mention the rhyme scheme and you come right back to sonnet. But in the second case, there is no such mutuality of references, no *system* of asso-

ciations. Mention Dempsey, who would ever get back to sonnet? System is mutuality of reference among the strands of a texture. Of course, there are other kinds of systems besides types. Social structures and schemes are also systems. Types are systems that are intrinsic to their objects and repeatable in other objects: they are intrinsic-extrinsic systems of organization.

How can types, if this is the sort of thing they are, be made unexpected and novel enough not to be merely dead weights of organization in the works of art to which they give structure? The answer is to make them intricate and difficult enough of fulfilment to render their total fulfilment rare, and surprising, and in a way dramatic. For a difficulty in the fulfilment of a type amounts to an obstacle set in the artist's path, so that a drama emerges between the artist and his materials. If this drama is not overplayed, the materials acquire an extra modicum of vividness through the very agency of their organization.

This point is so interesting that I wish to interpolate a somewhat extended illustration. It has to do with the technique of story-telling,

which, as the *recognition* of a skill is, of course, a type. Henry James is here criticizing Conrad for somewhat overplaying the drama between the storyteller and the materials of the story to be organized. James begins by describing Conrad's peculiar indirect method of setting a story before readers, that of having a character tell what another says he in turn was told by a third, and so on. Or in Henry James's words: "Mr. Conrad's first care is expressly to posit or set up a reciter, a definite responsible intervening first person singular, possessed of infinite sources of reference, who immediately proceeds to set up another, to the end that this other may conform again to the practice, and that even at that point the bridge over to the creature, or in other words to the situation or the subject, the thing 'produced,' shall, if the fancy takes it, once more and yet once more glory in a gap." James then explains the narrative difficulties of this method, how it tends to disintegrate the objective character of the story, that is, its fused quality, and to diffuse the attention analytically over the separate wires of technique being pulled in the telling of the story: "It is easy to see how heroic

the undertaking of an effective fusion becomes on these terms, fusion between what we are to know and that prodigy of our knowing which is ever half the very beauty of the atmosphere of authenticity; from the moment the reporters are thus multiplied from pitch to pitch the tone of each, especially as 'rendered' by his precursor in the series, becomes for the prime poet of all an immense question — these circumferential tones of having not only to be such individually separate notes, but to keep so clear of the others, the central, the numerous and various voices of the agents proper, those expressive of the action itself in whom the objectivity resides." And then James's critical comment: "It literally strikes us that his volume sets in motion more than anything else a drama in which his own system and his combined eccentricities of recital represent the protagonist in the face of powers leagued against it, and of which the dénouement gives us the system fighting in triumph, though with its back desperately against the wall, and laying the powers piled up at its feet. This frankly has been *our* spectacle, our suspense, and our thrill; with the one flaw on the roundness of it all the fact

that the predicament was not imposed rather than invoked, was not the effect of a challenge from without, but that of a mystic impulse from within" ("Notes on Novelists," pp. 347–9). In other words, Conrad is acting a little like a virtuoso who selects a piece mainly for its difficulty and not for the quality of the piece. He to some extent tells a story to show off his narrative prowess and not to tell the story. We marvel at his technical success. But the success in this instance makes a gap between the technique and the material, and the material really is not organized by the technique. The work has not the structural spread of quality it might have had, if the artist had been less ambitious or self centered. The technique has run away with itself, like a horse that has broken from its carriage. The horse gets safely and rapidly home to its stall, but the carriage and its contents are left in the road out in the country.

What Henry James brings out about Conrad's technique is an allegory from which one may infer all the æsthetic merits and dangers of types. For a technique, as we said, is a type. And if it is a valuable type, the technique is intricate and

difficult. Its intricacy and difficulty make its fulfilment rare and novel, and so give it great potentialities for vivid recognitional quality. But if the intricacy and difficulty stick out, the type separates itself from its material and fails in its function to organize. At least, it fails to organize as far as it might have done, if it had not made itself and its difficulties so conspicuous. Excellence in the fulfilment of type, therefore, consists in the complete fulfilment of an intricate and difficult type, which nevertheless so fuses with its materials that the difficulties involved are not conspicuously felt and the type seems to be nothing more than the natural relations of the materials. It is art that conceals art. And yet the sense of the type must also be there, the feeling that this instance of the type is a member of a family having other instances. A person who reads a sonnet and does not know it is a sonnet, who reads a story and does not know it is a skillfully told tale, has not read the *sonnet* nor fully appreciated the tale.

When types are seen in this light, not merely as sets of rules to be complied with, but as agents for evoking vivid recognition which fuse with

the qualities of the materials organized, then the task of the critic in determining the success of types in use is seen to be not as simple as it appears at first. The critic who checks off the rules may easily miss the most important æsthetic point in the very fulfilment of these rules. For, as we have sought to show, it is not their bare fulfilment that registers their full success in a work of art, but their powers of evoking vividness of recognition and fusion of form and materials. The perception of these powers is as delicate a matter of taste and judgment as the perception of any phase of æsthetic quality.

Through recognitional quality, therefore, types acquire a life which would hardly be credited to them on the basis of their thoroughgoing conceptual nature. That they have extensive and rigorous organizing capacity, no one would question. But one would think their rigidity would make them dead and lumpish. So it would but for this recognitional quality, which by good luck (or rather, by the very necessity of the conditions) attaches with especial vividness to the most intricate, and there-

fore the most highly organizing types. Thus, another paradox emerges: the maximum of purely conceptual organization generates a maximum of quality; a quality, moreover, that arises not solely from the materials organized, but out of the very structure of the organization itself. For recognitional quality is vividness of recognition of the type itself.

To clench these various points, and also to exhibit the enormous amount of organization performed by types in art, I shall now rapidly list and comment upon some of the most important sorts of types employed in art.

We may begin, since we have just been talking about them, with types of technique. A technical type is the organization of principles of method for handling materials. When technique is mentioned, we generally think first of performers' technique, the technique of a violinist or an actor. Certain kinds of art like music and drama require the interpolation of an interpretive artist between the original creative artist and the appreciator. This physical separation of the creator and the interpreter of the work of art raises to exceptional prominence the tech-

nique of interpretation. We often literally see the technique separated from the material—the one in the body and movements of the performer, the other in the pages of music he turns over. If the technique is not quite perfect, or if our attention relaxes a little, we often find ourselves listening to the performance of the notes rather than to the qualitative whole of the tone structure. But, of course, a perfect performer's technique is one in which no such separation takes place—except through ignorance or other weakness of the spectator. At the same time, a perfect performer's technique, even of a very simple piece, is a highly intricate and difficult type. The full skill of a violinist—his production of a clear, rich tone, his sensitive phrasing, his power to bring things out of a piece—shows itself to a trained listener as plainly in an unconceited straightforward piece as in the most elaborate bravura concerto—more plainly. And it is ridiculous to think that the appreciation of the piece is not enriched by the sense of the subtleties and intricacies of the technique. Furthermore, this performer's technique is precisely what puts the piece in order for its

presentation to the hearer. The performer is the expert organizer, within the limits suggested by the composer, of the actual physical sounds which are presented to the listener. If he fails in this function, either by underdoing it or overdoing it, we lose some of the quality of the work he is interpreting. If he does it to perfection, and we have the knowledge to discriminate the subtleties of his skill, our recognition of these themselves sheds a special glory over the piece. The appreciation of performer's technique is a very pertinent matter; but it must not be an admiration of scattered acrobatics, it must be a recognition of the skill of organized presentation.

What applies to the appreciation of performer's technique applies equally to the appreciation of composer's technique, and even more obviously. Here also there must not be a gap between the technique and the material. A loss of quality is certain to ensue. And it needs no argument to show that all excellent art involves intricate and difficult skill in its composition. This remark is even more true of works we call romantic than of those we call classic. It is a

queer idea that something composed in the heat of emotion should require no technique for its excellence. That the technique is not prominent, that it is melted down and amalgamated with its materials, that it is intricate, varied, and subconscious—these are the very characteristics of technical excellence. And it should be added, for all that we have insisted on the discrimination and the potential analysis of technique or of any type for the full appreciation of that type, there are few intricate types that do not involve features which lie beyond our range of analysis. An intricate type, for all its apparent sharpness, has fringed edges. It is easy to mistake this fringe for absence of form. Sometimes we recognize, but do not quite know what it is we recognize.

Closely akin to types of composer's technique are formal types. These are stereotyped modes of composition, such as the sonnet and the sonata form, which we have already used as examples. These differ from composer's technique in that a technique is a skill which when applied to varied materials generally yields varied results. So far as an artist's skill is concerned, he might

never compose two works of art alike though he used the same skill in every composition. But a formal type is precisely a partial repetition of a composition. The framework of some specially successful composition is repeated and becomes stereotyped and recognizable. The degree of rigidity of the formal type required for satisfaction in recognition varies from form to form. A sonnet has to be strictly followed in its principal features or we are jarred into intellectual analysis and a diminution of quality. On the other hand, musical forms are recognizable and not objectionable even when very freely treated. It is not easy to find "normal" illustrations of sonata form or fugue in the best classical literature of music. In formal types there is generally an inner set of rather rigid requirements together with an outer set of alternative requirements, or of limited ranges of freedom, or of merely preferred usages. So formal types become a good deal like manners in society, and, in fact, actually shade over into funded social structures. An architectural style such as the Gothic, for instance, stands in this ambiguous position between a formal type and a religious

social structure. A judgment of whether or not a work of art fulfills a formal type is a good deal like judging whether a man has good manners or not; and our immediate feeling of the character of the work is tinged by this judgment.

Speaking of architecture, another important group of types is that of types of utility. If an object serves some human purpose, the system of requirements that would satisfy this purpose constitutes a type. The system may be pretty complicated even in so relatively simple an object as a chair or a wineglass. It becomes enormously intricate in an object like a building. And the appreciation of the building depends fundamentally on the sense of its serving its function and serving it with completeness and economy and distinction. It is often unnecessary for a building to be anything else æsthetically than the fulfilment of its functions. Its quality then resides in its functions; and the perception of its beauty is the recognition of the adequacy and competency of the intricate fulfilment, the recognition of the unwasteful and apparently inevitable adjustment of function with function.

Even when the charm of practically super-

fluous decoration is added to the functional quality of a building, we demand that the decoration grow out of function or, at least, be not inconsistent with it. This is what sincerity or veracity in architecture consists in. Not but what some beautiful buildings in some degree lack these characteristics, but that the lack is always a blemish. A building is so obviously a thing of use that any discovered neglect of function creates a practical revulsion, and drains the object of quality; and conversely the discovery of any unexpected niceness in the fulfilment of function sheds vividness of quality not only on the structural features involved but even upon the neighboring decoration.

What function does for architecture, representation does for painting and sculpture and, in a different way, for narrative literature and drama. The internal structure of these arts is largely derived from what I shall call natural types. A natural type is a system of characteristics descriptive of environmental objects or events. What we mean by a lion, or a whale, or a live oak tree, or a wave, or a cloud, or a running brook, or a man, or a legislative as-

sembly, or a national election, or any such, is a natural type. The description of any of these in a work of art is a source of recognition. If the natural type has been searchingly discriminated and competently represented, the quality of the structure is vividly felt.

The secret of representative beauty is this searchingness in the discrimination of a natural type. A superficial representation of objects is as trivial in art as the passing of people on the street in life. It is not representation itself nor even faithfulness of representation that counts. It is the degree of penetrative observation. It is perception. This has nothing necessarily to do with the number of features of an object set down on paper. Most features can be taken for granted. The vivid recognition of a natural type in art depends as much on what is omitted and understood between artist and spectator as on what is depicted. A few traits may be enough to suggest all the rest. There is nothing so dull as a catalogue of traits, and the stimulation of the imagination is of itself a source of vividness. Selection and accent are more essential to vivid representation than quantity. Three

words of Wordsworth's are more revelatory of a character or a scene than three pages of a less perceptive writer. One line of Rembrandt's tells more of the attitude of a figure than all the little brush strokes of Meissonier. On the other hand, a skillful deploying of a multitude of traits is also a means of reaching into a type, as Balzac and Thomas Mann have shown. The means is not the question. But the penetrative perception is. For only thereby does an artist work into the character of an object and call up the difficult and intricate type, which lies within it, and which alone brings revelation and vividness of recognition. Only thereby do we see into an object, realize it, feel it real.

There are, accordingly, many degrees of omission of detail in excellent representation. But some omission is always necessary, otherwise the result would not be representation, but an example of the real object itself. The artist, far from attempting to conceal the distance between the real object and his representation, takes special pains in exhibiting it. He puts his picture in a frame, his statue on a pedestal, his drama on a stage to accentuate the distance. He has

many reasons for doing this, one of the most important of which is the preservation of the individuality or the organized totality of his work. For his employment of natural types is not with the purpose of deceiving people, but of gaining spread of quality. If, by chance, spectators become deceived and fall into the illusion that the artist's creations are physical objects, then a practical attitude develops and the recognition of the type instead of organizing quality drains it off. The longshoremen in San Francisco who it is said rushed up on the stage and nearly beat up an actor in the character of a strike breaker, stopped the play, and considerably interfered with its qualitative individuality.

All representation, therefore, involves omission. The fulfilment of natural types lies always somewhat, and often mainly, between the lines, and is consequently always more or less symbolic. Here again we see how shadowy is the line between purely extrinsic organization and organization by types, and we see how great a burden is placed upon the spectator in the appreciation of representation. He must know the type almost as intimately as the artist. The spectator

does not have to make the selection. But for his appreciation, he does have to know from what parts of the type the selection has been made; otherwise the selection will not appear to him to symbolize the whole type, but will simply seem a funny group of traits, or may not seem to be even traits at all, since he has failed to see deeply into the type to which they are attached.

But this obligation on the part of the spectator to keep his knowledge of types up to that of the artist is as mandatory for other types as for these which are the basis of representation. One cannot, to be sure, appreciate good draughtmanship in painting without a more discriminating understanding of the construction of the human body than the ordinary man in the street is likely to have. But neither can one appreciate a technique or a form or a practical function, as these are incorporated in excellent art, without knowing more about them too than the man in the street. The artist may himself through his works be our teacher in these matters. But acquire an intimate knowledge of these types we must or we fail not only to perceive the organi-

zation rendered by the type but actually to real-
ize what is presented.

For a type is not merely an organizing tool,
it has a character and a quality of its own. In
excellent technique we identify this character
with the personality of the artist, in excellent
achievement of function with the quality of the
interests served, in excellent representation with
the essence of natural objects. If the fulfilment
of type is excellent, the gap between organiza-
tion and matter organized narrows and fills up,
and the organization is the simple and inevitable
movement of the matter, and the matter just
the realization of the organization. The hostility
between intuition of quality and analysis of rela-
tions then ceases. Discriminating analysis then
reveals the quality and the quality is the revela-
tion of the analysis. If this miracle appears
impossible, it is nevertheless a fact, and a fact
as common as the act of full appreciation of
excellent art.

Chapter VII

PATTERN, AN INTRINSIC MODE OF ORGANIZATION

In extrinsic organization a work of art participates in structures which it can never incorporate within it. In organization through types it incorporates or potentially incorporates whole structures, which, however, have existence independent of the work of art. But in intrinsic organization the structure is created by the artist within the work and exists only in the work.

There are two kinds of intrinsic organization. The æsthetic purpose of organization, we must remember, is to increase the spread of quality. The reason that quality does not have unlimited spread for human intuition is obviously due to limitations physical or human. It is two human limitations which determine the two different kinds of intrinsic organization. One is the limit of human attention, the other the limit of human

interest. The function of intrinsic organization is artificially to increase these limits. We need not feel downcast that we have these limitations and have to work to expand them. What art, not to say life, would be like without them it is hard to conceive. There is no reason to believe that we should prefer it. A game is nothing without its rules limiting actions; life might well be nothing without its limitations.

But however this may be, of one thing we may be certain: that just as different rules make different games, a different set of limitations or even a relaxation or a restriction upon our present physiological limitations would make a totally different life for us and a totally different art. The intrinsic structure of art, which we are about to study, is nothing other than the reflection in art of the particular structure or limitations of human attention and interest. The result of the limitations of human attention on art I shall call pattern; the result of the limitations of human interest, design. I am giving these two words a distinction of meaning which they undoubtedly do not have in common usage. But the need of the distinction is evident.

The way to be sensible of the limited range of human attention is so far as possible to break down the interconnections of strands of events, to obtain as isolated strands as we can, and to see how many of these we can intuit at once. This is a highly artificial procedure and can only be approximated, but it can be approximated by selecting one of the ultimate elements of any analytical scheme and seeing how many instances of this element can be clearly taken in by a single act of intuition. How many dots can you clearly distinguish at once without counting or grouping, or how many successive raps on the table. You will find that five or six is about the limit that can be easily taken in. It is very hard to avoid grouping or counting when more than five or six dots are offered. But one hardly thinks of grouping or counting for three or four dots. Well, this is what is meant by the range of attention.

But besides this limit of range, attention has another kind of limitation. This consists in one of two principles I was warning against in the last paragraph—namely, grouping. I need not say anything about counting. That is clearly

the application of a socially developed organizing scheme, and has nothing to do with the nature of attention. But grouping has. Grouping is the attention's natural way of making up for its limitation of range. It cannot take in nine units in an undifferentiated act, but, as three groups of three, it can. The attention has a strong tendency to break up large numbers of units into groups of twos and threes, though if the units are rapidly given, or under certain other conditions, it will accept groups of fours or fives or sixes. Now, these tendencies for grouping, together with the limitation of range of attention, constitute what I call the structure of attention.

This structure, even before further comment, is obviously something that is bound to have a strong influence on the disposition of materials in a work of art. In fact, it has a decisive influence, for failure to conform to the structure of attention is precisely what we mean by disorder, and disorder is a direct source of practical unrest and therefore of the draining away of quality.

From this perception, however, it must not

be assumed that every instance of confusion is the artist's fault. There are other modes of organization besides that of the structure of attention, and disorder may result from the spectator's failure to grasp some other organization, with the result that too great a strain is put upon that spectator's attention. For example, if a spectator fails to grasp a type, the work of art breaks to pieces so far as that source of organization goes, and there is nothing left to organize the fragments but attention, which is inadequate to the task. Disorder results. But the fault here lies with the spectator and not with the artist, who assumed that the spectator would know enough to know the type. And when the type is known, then attention is adequate to perform the remaining work of organization. The work is then not disordered, and its quality can emerge. Attention does not have to, and in general does not, perform all the work of organization in a work of art, but it is the fundamental and never to be neglected determinant of organization.

A consequence of these observations, not always sufficiently noticed, is that a work of art

may be thoroughly organized within the structure of attention without being unified in the strict sense of unity. For a reason I shall presently explain, a good example in excellent art of adequate organization without unity is hard to find. But the regular tripartite form (ABA) of classical music comes near having this character. The A section is probably unified in the strict sense, by dominant emotion and the type of tonality and other means, and the B section similarly unified. But the A and B sections far from being unified are contrasted. Now, I am aware that it is customary to assert that contrast is a sort of unity. And in many instances the assertion is true. In art it is generally true, since an artist tries to do as many things at once as he can. But in essence the assertion is false and covers up the very distinction that makes contrast a factor in composition different from any other factor. It covers up the very distinction which makes the organization within any one of the sections (A or B) different from the organization of the sections into one piece (ABA).

Dominant emotion unifies strictly, so does

type, so does participation in a funded social interest or in a scheme or scale. But contrast in principle and in intent *multifies*. The intention of the B section is precisely to have *not* the emotion of the A section, *not* the same tonality, and, though it cannot get out of the scheme of sounds and still be music, it may very well *not* be in the same scale. The artist does at least enough things that are *not* the factors which unify the A section, to make it plain to any listener that the B section is not contributory to the organization of the A section, but is a distinct and different and separable section.

Whence, then, the organization of the piece? Why, in the structure of attention. Even barring the fact that the last A section repeats the first, a work of art consisting of three distinct sections is well within the range of attention. And the more distinctly these sections are differentiated, the more easily can attention take them in. There may even be four sections as in the four movements of a symphony, or five, and still there would be clarity of organization without, in the strict sense, unity.

What, then, happens to individuality of tex-

ture, which we have been insisting upon as the basis of quality? Why, the structure of attention itself furnishes that individuality. For the structure of attention is the very structure of that experience, and to realize that experience is to discriminate that structure in it. There is no danger from analysis and overdiscrimination in such a case, because the whole structure is intrinsic to the experience, and realization of the structure is part of the realization of the texture, and the finer the discrimination the fuller the realization. To realize the distinct ABA sections with all the contrast involved is fully to realize the quality and individuality of the piece.

The conditions of the situation are even more favorable to the artist than I have suggested. For it is unexpectedness and shock that stir men to discrimination. The shock of contrast, accordingly, of itself stimulates discrimination of the qualities of the contrasted sections, and does this in the present situation without necessarily leading out of the work of art at all. The span of attention itself organizes the contrasting elements, which through the shock of contrast

generates vividness of quality. The very possibility of all this lies in the fact that a work of art may be organized without unity, in the strict sense.

Why, then, with so many advantages to be gained without unity do works of excellent art always (I think I may safely say so) have unity in some degree? For two reasons. First, because works of excellent art are generally rich in material and the structure of attention would be overstrained in organizing alone so much matter. And second, because the shock of contrast is increased, and consequently the ensuing vividness of quality, if the contrasting elements are also in some way related and to that degree unified in the strict sense. In other words, the strongest contrasts occur among related, not among unrelated, elements. And the stronger the connecting relations the more vivid the contrast, provided the opposition creating the contrast can stand up against the strength of the connecting relation.

So the key of the dominant is in stronger contrast to the key of the tonic than more distantly related keys just because it is so closely related.

It was fortunate for our tonal music that the most nearly related keys should be the very ones that in other respects were most opposed to one another. The key of G, for instance, has all its notes but one (F ♯) in common with the key of C, and is consequently closely related to the key of C. But at the same time, by good luck, the tonic of the key of G (namely G) which is the center of tonality for that key is farther from either tonic of the scale of C than any other note (except F, to which C is as G is to C). We obtain a close connection of constituent tones together with a wide opposition of tonality. No imaginable arrangement of keys could be more favorable to the art of music than this. The close relationship of the two keys guarantees a high degree of unity, and at the same time the opposition of their centers of tonality guarantees contrast. Moreover, since the opposition occurs within the unified type system of tonality, the contrast takes on the form of a conflict and generates vividness of quality.

No artist can be expected to forego the advantages of such a situation as this. He arti-

ficially induces unity, therefore, even when his work might be sufficiently organized by contrast only—that is, by the structure of attention only. Thus, the typical tripartite form for music is not ABC, which, so far as the structure of attention goes, is a sufficiently organized form, but ABA. The repetition of the A after the B, by springing a close connection from the first over to the last section, makes the second section stand out in still stronger contrast and increases its vividness. I say nothing just now of the æsthetic advantages of recognition arising from the repetition of A, and what that does to the vividness of A.

In excellent art, therefore, we cannot expect to find examples of organization by means of the structure of attention alone. But the covert if not overt working of the structure of attention in æsthetic organization is never absent. There is no art without pattern—pattern, as we have defined it—no art that does not conform to the structure of attention. Many structures that appear by other names in art are really attention structures. One of the most pervasive of them is what is called rhythm.

PATTERN

Rhythm is generally associated with the time scheme, and defined as a succession of repetitions in time. The important thing to notice, however, is the structure of the matter repeated. Whether it is a measure in music or a foot in verse, it is noticeable that the number of elements in the repeated pattern is always less than seven and, except rarely, more than one. In other words, the pattern of a musical measure or a verse foot is an application of the structure of attention; it is a unit attention pattern. Thus in music we have 2/4, 3/4, 4/4, 5/4, 6/8 time, but not (except parenthetically and for special reasons) 11/16, 13/16, or 17/32 time. The first five fall within the range of attention (indeed, 4/4, 5/4, and 6/8 times are generally internally subdivided or grouped for further security of pattern) but 11/16, 13/16, and 17/32 times involve too many elements for a unit attention pattern. And in verse we have iambs and trochees, dactyls and anapests, and rarely four element feet, but never seven, eight, or nine element feet. Unit patterns in music can be extended further than in verse, because the elements there are musical tones, the simplest of

all sound elements, while in verse they are whole syllables of words, which slow down the rapidity of movement and even the clarity of production. The basic or unit patterns of music and verse are, therefore, well within the range and easy grasp of attention.

This is true whether you take the regular implicit pattern or the irregular explicit pattern of music or verse as your basic unit pattern. Let me explain. Take the following line from one of Shakespeare's sonnets:

Shall I compare thee to a Summer's day?

In terms of meter, this is iambic pentameter, and would be represented as:

∪ ⁄ / ∪ ⁄ / ∪ ⁄ / ∪ ⁄ / ∪ ⁄ /

The unit pattern is a two-element foot with the second accent strong and the first weak. But no one should read the line that way. The reading of the line would go something like this:

⁄ ⁄ ∪ ⁄ ∪ ⁄ ∪ ∪ ⁄ ∪ ⁄ /

This is the explicit pattern. The other regular pattern is only implicit; it is felt, but not said

or heard. The rhythm of the verse is a simultaneous combination of these two patterns. The effect would be different if either one were lacking. If the implicit pattern were lacking, the effect of the line would be prose; if the explicit pattern were lacking, and the implicit pattern made explicit, the effect of the line would be doggerel. The peculiar rich effect of the line is due to the two patterns weaving through each other in counterpoint, or in harmony of conflict.

Now, as I say, whichever of these unit patterns is taken as the basic rhythm of this poem, the pattern falls well within the range of attention. There would be confusion, if it did not. The two-element foot of the meter is well within the attention span, and the five-element explicit prose foot is also within the span. What holds in this manner in verse holds similarly in music. Here the measure corresponds to the implicit verse foot, and the explicit tones of the musical phrase to the prose foot.

These unit patterns are now built up into organizations according to the group structure of attention. The verse feet are gathered into lines and the lines into stanzas. In the Shake-

spearean sonnet, for example, each line has five feet, and the sonnet as a whole has its fourteen lines divided into three four-line groups and a final couplet. The elements of each group are well within the limits of attention. Though there were no organization through thought or emotion or type, in the poem, the sonnet would be thoroughly organized through the structure of attention. There is a total group of *four* elements, of which three of these four have *four* elements and one *two* elements, of which every one of these has *five* elements, of which every one has *two*. The structure is transparent to attention.

What stanza, line and foot are structurally in verse, period, section, phrase, and motive are in music. And in other arts we find the same mode of patterning by attention. Thus in architecture, the face of a building is divided into two, three, or five sections (rarely four, six, or seven) up and down or right and left. These sections are then internally divided within the range of attention, and these sections in turn subdivided. The façade of the Amiens cathedral, for instance, is divided into three vertical sections, a central

section and the two flanking towers. The towers are then divided into four horizontal sections, and these sections still further divided in various ways. An oriental rug, a Persian plate or vase, and objects of pure visual design generally are likely to have this kind of organizing attention pattern. I call it embracing pattern, from its manner of having each level of organization enfold the pattern of the level below.

But another common sort of organization by attention is what I call the skeletal pattern. The ground plan of a building on a system of axes has this organizing pattern—main axis which generates subordinate axes, which generate sub-subordinate axes and so on, like a tree with its trunk, branches, twigs, leaves, veins, and fibers. The plot structure of a novel has this sort of organization, and in some degree the tonality structure of a large musical composition. But it is in sculpture and painting that this sort of organizing pattern is most conspicuous. Here a simple form like the triangle as in so much Renaissance painting, or a simple combination of intersecting lines as in much Chinese and Japanese painting, is the trunk

from which spring a limited number of linear branches, from which spring linear twigs, and so on. A sort of combination of embracing and skeletal organizing pattern develops in the volumnar composition of much recent painting and sculpture.

Still another important mode of organization which has affinities with skeletal patterns, but is really very different, is what I call axial patterns. These are patterns involving a sense of balance, which in turn involves the feeling for an axis of balance. Symmetry is, of course, the simplest example. Spatter a blot of ink on a piece of paper, fold the paper down one edge of the blot and press the two sides together so as to double the blot. The order that comes out of such a doubling of confusion never ceases to be something of a miracle to me.

The peculiarity of symmetry is that every element on one side of the axis calls for and finds a corresponding and oppositely shaped element equally far away on the other side. We have here again that combination most favorable to æsthetic quality of closeness of relationship together with opposition. The result is pattern

in the strict sense (as *two* forms easily intuited as a pair because of their simple opposition), but more than pattern by the amount of the demand of element for element across the axis. This demand is something not involved in mere attention. Attention sets up limitations but does not make referential demands. These demands remind us of the demands of types. But symmetry is not a type. It is not extrinsic to the pattern. It is intrinsic, unlearned, direct, and immediate.

These referential demands give a dynamic character to symmetry, which is by no means to be ignored. And as symmetry passes over into balance, these dynamic references become more and more conspicuous and pattern properly speaking less and less so. Balance is a sense of equal weight of æsthetic material on either side of an axis but without the limitations of strict inversion of form and equality of distance from the axis. A larger form near the axis will balance a smaller form at a distance from the axis. A stronger sense of movement towards the axis will balance a weaker sense of movement away from the axis. A small feature of great interest

will balance a large feature of lesser interest. And so on. Pure balance arises when the æsthetic weight is equal on either side of the axis, and when there is no similarity whatever, of the sort that makes symmetry, between the features balanced. Since there are likely to be a great many features involved in a balanced composition, more than the attention can span or group, it follows that the organization is produced not primarily by attention but by the referential demands across the axis. And yet it is proper to speak of balance as a kind of pattern because of the essential *duality* of the arrangement. The axial demands divide the composition in *two,* and attention easily grasps that duality after the referential demands have done their own organizing work. A confirmation of the pattern character of compositions involving an axis is found in the fact that there may be *symmetrical* compositions across horizontal and diagonal as well as across vertical axes, but never *balanced* compositions across other than vertical axes. For symmetry is a relatively simple and transparent mode of composition. Attention, therefore, easily grasps a

PATTERN

composition divided into *four* parts resulting
from an up-and-down as well as a right-and-
left symmetry—resulting, that is, from a hori-
zontal axis crossing at right angles in the middle
of a vertical axis. And if two diagonal axes
are passed through the point of intersection of
the horizontal and vertical axes, dividing the
total composition into eight symmetrically re-
lated segments, the attention can still span the
number of elements. But nothing of this sort
can be done with balance. The internal com-
plexity of the references producing pure balance
is so great that confusion would result if atten-
tion were strained beyond duality.

It is clear, however, that there is no sharp
line between symmetry and balance, for ele-
ments of balance may be introduced into a pre-
dominantly symmetrical composition (as in early
Renaissance altar pieces) and vice versa. But
the closer a composition approaches pure bal-
ance, the greater the strain upon our organizing
powers.

We will nevertheless endure and on occasions
demand unbalanced compositions, which place
an even greater strain on our organizing powers.

An unbalanced composition is an axial pattern in which the elements on one side of the composition outweigh those on the other. This is different from saying that the composition is without a sense of axis. Non-axial compositions do also exist. But an unbalanced composition is one in which an axis is strongly felt and yet one side of the axis is deliberately heavier than the other. The bright and piquant character of such compositions arises from the shock of conflict with our expectation of balance. But these compositions have to be handled with taste and tact, otherwise they lead to confusion or practical discomfort, or that disrupting analytical enquiry, "Why?" What is just the right angle for a lady's hat? There is the question of unbalance in a nutshell. It depends upon the styles, and upon the lady, and upon a lot of other things. It can be overdone, and not done enough. The taste of an architect in designing the ell of a house or an unbalanced slope of roof is not a bit different from that of the lady, except for the greater seriousness and durability of the materials.

Having mentioned the referential demands of

axial patterns, we are in a position to perceive the same sort of thing in repetitional rhythmic patterns. A few repetitions of a unit pattern—under certain circumstances, only two—are sufficient to set up expectations of repetition, that is, a specific set of referential demands. An internal dynamic projective push thus enters into pattern, and this factor is rather more prominent in the orthodox connotations of rhythm, than the factor of pure pattern, which is furnished by the structure of attention.

There develops even a little conflict between these two aspects of rhythm. The purely pattern or attention aspect continually tries to gather up the units into groups that will be self-contained, while the dynamic aspect continually tries to reproduce and spawn elements indefinitely into large careless families. In excellent art the pattern aspect of rhythm generally keeps control of the situation, but, every once in a while or in parts, the dynamic aspect runs away with matters and proliferates in freedom. In poetry, for instance, pattern lays no restrictions on the repetition of stanzas. By a sort of general agreement among poems, rhythm is kept strictly

within the bounds of pattern through foot, verse, and stanza construction, but after the stanza construction is reached the dynamic aspect is released and can go it for all it is worth. The same sort of freedom we find in colonnades, balustrades, panelling, and fenestration in architecture, in the unrestricted repeats of textile and ceramic design, and in sections of persistent rhythm in music.

The dangers of this dynamic freedom are obvious. If it avoids confusion, it is only to run the risk of monotony. The places and the occasions of its use in good art are revealing, and teach us a lot about what might be called the interior motivation of æsthetic composition. Why, for example, do textile designs, china and pottery designs, furniture designs, and so on, make much greater use of these free repetitive rhythms than any other kinds of art? Evidently, because they are not objects intended to catch and hold the attention for long. They are the objects we have about us for our everyday living. A chair as insistent upon recognition as a Michelangelo statue should be put in a niche or on a pedestal. It is too superior for a

chair. A well-mannered chair is retiring in its composition, and a relatively monotonous pattern is appropriate to it. We take in the form of the chair, see at a glance how its pattern runs, and are content to sit down in it. If we have time or are so minded to look closer and discover its good workmanship and some subtleties in its pattern, we appreciate the quality of the chair. But a chair is primarily a thing of use, and if it calls too loudly for æsthetic attention it actually loses in æsthetic character.

But it is even more revealing to observe where the unrestricted repetitive rhythms come in the major arts. Whether the organizing pattern is of the embracing or the skeletal form, there are larger and lesser units of organization. Now by the nature of the case, it is the largest units that first receive attention in spatial organization, while in temporal organization it is the smallest. In a building it is the arrangement of the big masses that we first perceive and afterwards work down to the proportions and distributions of windows and doors, piers and capitals and moldings. In a poem, on the other hand, it is the words and syllabic sounds that

we first notice, and thence we work up to the lines and stanzas. It is, therefore, important that the large units be particularly interesting in a spatial work of art, and the small units in a temporal work of art. Consequently, we should expect unrestricted repetitive patterns to occur mainly among the lesser units in spatial works of art, and among the larger units in temporal works of art. And that is exactly what we find. It is stanzas in verse that are unrestricted in their repetitions. It is window openings, the details of moldings, steps, and the bars of railings that are unrestricted in their repetitions in architecture. It is æsthetically better that they should be so. Being far away from the main objects of attention, they do not seem to call for any more intensive organization than the and-so-forth type; and being monotonous, they send the attention back to the objects of main and intensive interest. Besides, these unrestricted repetitions, held in suitable bounds as they always are in excellent art, behave as sources of contrast to the areas of intensive restricted pattern and augment the quality of these latter areas. The monotony of steps makes

us realize all the more vividly the proportions of the stairway, and the monotony of stanzas the quality of words and imagery.

But already in talking about pattern we find ourselves discussing design. For monotony and contrast are matters of design, not of pattern. So, let us immediately turn to these matters.

CHAPTER VIII

DESIGN, AN INTRINSIC MODE OF ORGANIZATION

PATTERN is based on the limitations of attention, design on the limitations of interest. As in pattern we sought out the lower limits of attention by seeing what happened when attention was held to abstract elements like taps and dots, so in design we can seek out the lower limits of interest in the same way. How long can a man keep up interest in a single tone droning continuously or in a single dot? Not for long. The experiment, in fact, is almost impossible to perform with full satisfaction, because distractions immediately set in so that the dot or the tone is never quite alone in our thought, and how much these distractions have to do in keeping up some degree of attractiveness in the element is very hard to determine. The dot becomes the center of an invisible circle, or turns into a tiny beetle, or suggests a fly-spot, or a

period, or a decimal point. Moreover, it flickers. Hold our eye on it as we will, it comes and goes, and is no longer a continuous dot but a repetition of dots. And suddenly we realize we have for some moments not been seeing the dot at all, our thoughts having roved far away. There we see the lower limits of interest.

And we see also what interest spontaneously tries to do to keep up interest. Just as the attention seeks to extend itself by grouping, interest seeks to extend itself by variety. Its inventiveness in this direction is astonishing. The structure of interest, so to speak, is variety. And just as with attention the artist builds up patterns by following and exploiting the natural tendencies for grouping, so with interest he builds up designs by following and exploiting the natural tendencies for variation. These tendencies will obviously be our main concern here. But there are two relevant matters we must consider in advance.

One of these is the matter of drives. The example of interest with which we have begun is from one point of view a very unfair one. A dot might be regarded as a better example of an ob-

ject of unconcern than of an object of interest. If we wished to illustrate an object of interest, we should have chosen something like the sight of water to a thirsty man, or of a young woman to a young man, or of money to a miser, or of a voter to a politician. A mousehole is not much larger than a dot, and a man would not have much more interest in it, but a cat will sit and look at it for hours. What creates interest is drives, and any object of a drive is a source of interest with a capacity for holding interest proportional to intensity of the drive.

Certainly no one would wish to deny the substance of this objection, nor to deny that these drives are of supreme importance in art. They are a fundamental source of vitality as we pointed out long ago. They are the materials of dramatic conflict and emotion. But it is just because they are the sources of such intense interest that they are not good material for exhibiting the structure of interest.

It is often a matter of amazement, even to persons well versed in art, how strenuously some artists avoid interesting subjects. But we now begin to see the reason. These artists are men

particularly interested in design. They are the men who prefer to construct interest rather than prospect for it. They are perhaps the artists *par excellence,* and they are likely to be very scornful of the prospecting species of artists. We have just been passing through a period of painting in which this attitude is especially conspicuous. Cézanne is its chief prophet. A table cloth, a bottle, and a few apples suit him better than forests and mountains, and if he paints the latter he paints them like rumpled table cloths and bottles. For Cézanne is building up designs, and he abhors the intrinsically interesting subjects, which his followers now call "literary," because he wishes no other interest to cut across the interest he is constructing out of design. Even if the meadow he selects to work upon is luxuriant with natural interest, he will plow this all in and plant his own garden, so that the fruit he picks will be all the result of his own labor and planning, and none of it fortuitous. Being the sort of artist he is, he is undoubtedly right in doing this. But what becomes as astonishing as his wilful destruction of rich natural interest is his construction of a still richer artificial interest for

those who can follow the construction. And, it may be said, he gains by this procedure a certain kind of objectivity, because natural interests depend upon the disposition and appetite of the spectator, while an interest constructed by design before one's eyes demands only the concentration of the spectator and a capacity to discriminate colors, lines, and masses.

There is thus a certain antagonism between design and what we have called the dramatic in art. The interest in dramatic subjects can (given the appetite) be taken for granted. These interests come from drives within action patterns whether these latter be instinctive or cultural. And the danger with these intense interests is that they may run off into practical action and be drained of quality. They have to be restrained, and checked one by another, to guarantee quality—whence the art of dramatic conflict. Composition in this art consists in skillfully introducing brakes and obstructions to hold these interests back till their quality can be felt. But design becomes necessary when the elements are weak in natural interest and when there is danger that the interest may run out. Composition

here consists in skillfully introducing new and ever new elements of weak interest to keep the total interest up. And it is easy to see how an artist becoming absorbed in the skill of designing should resent a strong dramatic interest breaking in upon his delicate construction and requiring another kind of composition to hold the disturbance in place. His resentment turns to fury when some tactless spectator praises the dramatic subject and misses the design.

Nevertheless, there is very little great art that does not have a combination of design and natural interest. The antagonism between the two is itself a source of quality when carefully managed. In fact, features of design may themselves acquire a strength of interest through their development into types. Tonality in music is a fine example of this, as also certain musical forms. Music, of course, is predominantly an art of design, because of the rather small amount of natural human interest in sounds. For this reason music is given the place of honor among the arts by many writers. But with equally good reason, of course, music might be put at the foot of the ladder. If it is the most abstract art, it

must also be the least human. There is no sense in either rating. The moral is simply that there are many modes of composition in excellent art. Skillful design is a great source of beauty, but so also is human interest.

The second preliminary matter that requires mentioning is sensory adaptation. Our various senses, with two notable exceptions, are subject to fatigue in the sense organs and this constitutes an added source of concern to a designer in the arts. The first smell of the sea, the first taste of a fruit, the first smooth feeling of ivory is the most vivid, and quality in all these senses rapidly fades after the first few seconds of stimulation. Fortunately, sight and hearing, from which most of the sensory material of the arts is derived, are practically free from this deterioration. Hearing is entirely free from it, and sight as far as linear and mass discrimination go. But color is subject to adaptation. This means that color designing has to be especially carefully done—or rather that color unsupported by linear or volumnar form would be in as precarious a position as odor.

Never have I been so impressed with this

weakness of color as once when I was looking at the Grand Canyon of Arizona. One comes out of a pine forest directly upon the rim of the canyon and the whole great sight lies suddenly before the eyes. The sensuous beauty of the colors flows in over the body with a delicious intoxication. But soon I found that I was studying the shapes, the queer forms, with all their queerness ordered by the insistent horizontal stratifications, down to the lowest layer of Archean rock which suddenly tips up on end at the bottom of the canyon as tumultuous in its shapes as the wild stream that digs it out. Then again I thought of the colors. But where were they? In a sense, they were still there. I knew them as the same yellow, and red, and purple, and orange of the rocks, and the same blue of the sky. But where was the intoxication of them? I had to go back into the forest and come out again, for the colors to return.

In art colors are never as intense as in sunlit nature, and the reduction of vividness through adaptation never so striking, but nonetheless the effect is there and has always been prepared for in excellent art. When the sensuous charm of

color has faded, the skillful visual designer sees to it that a pattern of forms lies ready to take over the spectator's interest. One must not infer that color is, consequently, something superficial in art. Lines and volumes cannot compete with color in sensuous vividness, and almost always seem rather bloodless without color flowing through them. It is merely that color has an unfortunate susceptibility to adaptation.

We only note this fact, however, and say no more about it, because the means of avoiding adaptation are the same as those for avoiding monotony. Recourse must merely be had to them sooner. The means we refer to are the three principles of variety—namely, contrast, gradation, and theme and variation. We shall take these up *seriatim*.

Contrast usually, and gradation always, has to do with schemes. One cannot easily contrast a color with a sound, or even a color with a line, and one cannot at all grade from a color over into a sound, or from a color into a line. Colors are normally contrasted with other colors, lines with other lines, and sounds with other sounds. And gradations always occur along the dimen-

sions of sensory schemes. Schemes, therefore, are of importance in art not only as means of organizing fine discriminations, but as the foundations for two of the chief principles of design.

Contrast is the simplest and the most violent way of achieving variety. As interest begins to wane in a sensory element, a shift is made to another and generally a related element. The relation between the elements is generally as essential in contrast as the shift, for the attention alone does not easily hold totally diverse elements in comparison. The plumage of a bird is attractive and so is the ripple of a brook. But the two do not easily contrast with each other, since the plumage seeks other sights, and the ripple other sounds. But let a unity or an opposition of mood spring up between the two, and then they will contrast. Contrast does not absolutely require, but it does urgently beg for, a relation. Usually the relation that is depended upon (since every discriminating spectator acknowledges at least that relation) is the scheme within which the contrasting elements lie.

An immediate generalization follows: the further apart two elements lie in a scheme, the

greater the contrast. A very loud sound contrasts most strongly with a very soft one, a high pitch with a low one, a very light color with a very dark one, a very saturated color with a very dull one, a spectrum hue with its complementary hue, a short line with a long one, a wide line with a thin one, a straight line with a curve, and so on. These indicate the most violent contrasts. But the relief of contrast may be gained without going to such extremes. One does not have to go so far in contrast as juxtaposing thunder and a squeak; a mere raising or lowering of the voice furnishes a sufficient variety. Green is as good a hue to contrast with blue as the latter's complement, yellow. The shock of extreme contrasts is so great that artists usually prefer to achieve variety by the lesser contrasts.

The principle of contrast is, thus, simple enough but it has a great weakness, springing from its very simplicity. It very soon leads either to confusion or to monotony. And here we encounter a persistent dilemma of all designing. An artist in designing is always sailing a precarious voyage between a Scylla and a Charibdis. If he avoids the rocks of confusion in the

pursuit of variety, it is only to risk being drawn into the whirlpool of monotony in the pursuit of order.

Rhythm exhibits this dilemma as well as anything. A simple continuous sound is, of course, the most monotonous thing in the world. The easiest way to break the monotony is to break the sound with moments of silence. You then have two contrasting elements, and, if you repeat these, you have the ticking of a clock. But this turns out to be almost as monotonous as the original drone. Add a third element of contrast, and have a strong accent followed by a silence followed by a weak accent followed by a silence. Then we have the trochaic meter. This is better. Our interest holds up longer. But even a trochaic meter gets tiresome. However, we seem to have hit upon an idea for achieving variety: viz., the greater the number of contrasting elements the less the monotony. Fine, so let us get a lot of variety by putting together twenty different kinds of contrasting elements instead of just three. And there we come colliding into the limits of attention and our boat is shattered on the rocks of confusion.

To be sure, attention can do a lot for us by grouping our twenty elements into patterns, but then it is attention that is doing the work for us and not contrast. The principle of contrast working alone cannot achieve variety with more than the number of elements which mark the outside limits of the range of attention. In fact, contrast is more restricted than this. For the outside limits of the range of attention are determined by similar and not by contrasting elements. You can distinguish six identical taps in a single breath of attention, but not six elements one of which is a tap, another a squeak, a third a hiss, a fourth a bark, and so on. Four or five contrasting elements is the limit. That is as far as the principle of contrast can go in the achievement of variety without the assistance of pattern.

In this respect, gradation is a more effective principle of design. Its effectiveness, however, comes entirely from its insistence upon the order of the dimension of some scheme. So, twenty different pitches can easily be held together if they are running up a scale, or any number of hues if they are grading into gray. It is not

necessary that the steps of gradation be imperceptible, or even along regular intervals. There are perceptible leaps in a musical scale, and the leaps are not always equal. A chromatic run up the keyboard feels, of course, different from a run up the diatonic scale, or by thirds or fifths, or octaves. But they are all felt as gradations if they are done rapidly enough. So long as a movement along a dimension of a scheme in some direction is felt, so long does one feel a sense of gradation, and it does not make a particle of difference so far as the mere sense of gradation is concerned how many elements are strung along the dimension. The superiority of gradation over contrast as a means of achieving variety with many elements and still avoiding confusion is clear as soon as the principle is understood.

Furthermore, gradation has sometimes a peculiar feature of its own, which contrast never has, namely climax. If for any reason elements toward one end of a dimension of a scheme are intrinsically more interesting than those toward the other end, a sense of climax develops in the direction of the more interesting elements.

Strong intensities and large extensities, for instance, are normally more interesting, more compelling to the attention, than their opposites. An ascending gradation of intensities, such as an increasing loudness of sound, accordingly gives an effect of climax. Perspective gives the effect to colonnades and flights of steps, if one is near enough to them to feel a gradation of sizes. An artificial climax can be produced by externally stimulating a special interest in one end of a dimensional series, and this may even be strong enough to counteract an intrinsic interest in the opposite direction. So a vista with an object of strong interest at the end, such as the altar in a cathedral, creates an intense climax in the direction of that object *in spite of* the diminution in perspective sizes towards that object, though, of course, *with the help of* the convergence of perspective lines. Indeed, the opposition of climactic interests probably adds to the vividness of the dominant climax converging upon the altar. But the point I wish to stress here is the assistance which the gradation of *lessening* sizes gives to the climax of the vista. A mere perspective convergence of lines upon a blank panel,

such as one can have looking down a long hallway, misses the climax effect of a cathedral nave. The insistent breaking of these converging lines pier by pier and arch by arch in regular gradation towards the significance of the altar is the source of the intensity of this climax. And for the effect of the altar only go up to the apse and look back, and even with all the glory of the rose window, you see by the relaxation of the climax what the interest in the altar had done.

We shall presently learn of a broader meaning of climax than this which we have been describing; so I am going to call this, gradational climax. And we see that gradational climax is not only an instrument of organization, but also a powerful instrument of vividness and realization.

The third principle of variety is theme and variation. This has nothing specially to do with schemes, except in so far as these render the elements of a theme discriminable. A theme is any pattern composed of any sort of elements (but usually in art of visual or auditory elements) which is capable of recognizable repetition or variation. It must be a pattern in the

strict sense of the last chapter, otherwise it fails to be grasped as a whole and is consequently incapable of recognizable repetition or variation. Repetition is, of course, simply the minimum of variation. It is the theme varied in no respect except as to its time or place location. And repetition, as we have several times observed, is quickly subject to monotony. The value of the principle of theme and variation, accordingly, lies in the possibility of subjecting a theme to more radical variations than those of temporal and spatial displacement, and still having it recognizable.

Recognizability, thus, becomes the prime factor in the principle of theme and variation, and we are immediately reminded of types, which also depend upon recognition. Themes are, in fact, just the same sort of things as types, but are generated and developed internally to a work of art instead of externally. Themes are purely intrinsic modes of organization, whereas types are partly extrinsic.

The importance of the principle of theme and variation is that it extends the limits of interest further than any other single principle of de-

sign; it holds monotony longest at bay. It is best known for its employment in musical design, but no art does without it. It consists in taking a pattern, the theme, and making sure that this has been apprehended and can be recognized elsewhere and in other forms. To make sure of a full apprehension, the theme is set in a position of prominence in the work of art, and perhaps repeated. That is to say, significant gestures are made for the spectator to learn the pattern. It is, consequently, necessary that the pattern should be simple enough to be learned and become recognizable before any threat of monotony sets in. This limit of what a man can learn without fatigue, which limits the feasible complexity of a pattern, which in turn limits the possible variations that can be made on a pattern—this limit is all that prevents the principle of theme and variation from practically unlimited fruitfulness in design. But this limit is there. And a theme cannot be greater than a rather simple organization of elements. Even an eight- or a sixteen-bar tune, which is often called a theme in music, is composed of a distribution with internal variations of one, two,

or three rather simple patterns of not more than a measure or two each. The same is true of a visual motive in textile or ceramic design. What at first looks like a somewhat intricate motive, you find on scrutiny is really an organization of two or three very simple patterns, such as diamonds and ovals. You find that the principle of theme and variation has already been at work in what first caught your attention, and that the clarity of the more intricate pattern depends upon the simplicity of the motives that compose it.

Once the pattern is apprehended, however, then it can be varied to the very shadow of itself and still be recognizable, and the recognition following through all the variations constitutes the organizing thread that holds the design together and spreads quality as wide as the variations will go without monotony. At first the variations are likely to be rather conservative and easy to follow, but as the design extends itself they may become more and more bold and surprising, and the artist may even take the risk of your missing a variation for your delighted gasp of recognition if you catch it. And as with

types, so here, the more unexpected the recognition the more the quality not only of the pattern but of this very variation of it rises in vividness. The quality of the elements of the pattern themselves appear, the very pitch and interval or just that timbre of an instrument; and similarly with hues and shapes. So here again an organizing principle becomes also a principle of vividness.

There is a combination of the principle of theme and variation with that of contrast and the two with the structure of attention, so fruitful in design that it deserves a special name almost as if it were a separate design principle. We have already, as a matter of fact, talked about it in the last chapter. I call it segregation. It consists in alternating theme and variation and contrast in sections not more numerous than can be grasped by attention. A pattern of æsthetic material is presented and varied according to the principle of theme and variation to a point where monotony might set in. Then a contrasting pattern of new æsthetic material is introduced, and this again is varied as long as interest is strong. Then, either of two things

can be done: a new contrasting pattern can be introduced, or the old pattern can be repeated. The latter, as we saw previously, is generally the more satisfactory, because to the growing desire for contrast is added the recognition of something familiar. Here is the basis of the ABA form. If we now put some new variation in the repeat so that we get ABA', the design is still richer. And if each section itself is internally segregated, so that the A section becomes perhaps a tune of the form ABA'B'CB" CB" ', we have something still richer, and we begin to see the power of the principle of segregation. It passes out of the sphere of design and becomes a principle of systematic patterning. It is in fact a mode of systematic embracing pattern, and I did not expand upon it in the previous chapter simply because it involves principles of design for its comprehension.

The movements of a symphony are four segregated sections. Each one of these sections, according to the musical form of the movements, is itself segregated into sections. The third movement, for instance, normally has three segregated sections of the ABA form. And

then each of these sections is internally segregated into two or three parts, each part being a tune having segregated motives.

Exactly the same sort of segregative organization can be seen in oriental rug patterns. The surface of the rug is divided into big primary sections—a border, perhaps, contrasted with three diamond-like forms in the middle, these forms themselves contrasted with a central ground. Then there are contrasted sections within these larger sections. But the internal treatment of each section is in terms of repetitions or variations of a few motives. In visual design the motives of the segregated sections are likely to be variations of the shapes of the larger wholes, so that variation plays over the whole surface more intricately than in music. But the segregative principle is the same.

In textiles, ceramics, and architecture this segregative principle is obvious as a mode of visual design. But it must not be thought of as confined to the unrepresentative arts. In both sculpture and painting, it is employed to a greater extent than we are likely to realize. A Matisse, of course, is an oriental rug design

carried to the limits of subtlety, as are all Persian miniatures. But even Renaissance painting and the best of the naturalistic tradition with its attention mainly on texture, representation, and linear pattern was not unaware of the surface and volumnar patterns of segregative organization. I pick out an Ingres portrait of Madame Devauçay and find the areas of flesh, background, chair, dress, and shawl segregated off and internally varied as carefully as areas on a Chinese bowl. This segregative pattern would hardly be regarded as the dominant organizing pattern of the picture, but it is an important subordinate mode of organization.

Contrast, gradation, and theme and variation are the three simple design principles for the internal organization of æsthetic materials. There is a fourth distinct principle of design, which is on a different level from these. It is a principle for the marshalling of these principles. I call it restraint. Its source is the fact that interest itself grows tired, and that the artist must economize the spectator's total supply of interest, and not use it all up at once. Not that

interest within a spectator is exactly like water in a reservoir and is fixed in amount, but that it is something like that and can be drained off too soon to the detriment of the spread of quality.

Restraint is the principle that cautions an artist against filling a texture to the maximum of interest in every strand and trying to maintain that intensity of interest steadily. That itself would be a sort of monotony. Every area of a picture should not be equally interesting, nor every phase of a dance or musical piece. There must be resting places even within a work of art. Especially when an artist is preparing for an area or section of extreme interest, he has to prepare for it by surrounding areas or preceding sections of repose. When interest is gradually increased from one portion of a work of art to another, interest climax is generated. Gradational climax, of which we were recently speaking, is, we see, a case of interest climax, but a special case in which the elements must all fall along a single dimension of a sensory scheme. The materials of an interest climax have no such restriction and may come from any source.

The interest structure of a work of art in conformity with the principle of restraint is likely to take on a wave-like form, a rising and receding of interest, or rather a form like a mountain range, rising from the plains to foothills, thence to peaks, and descending to the plains again, with many lesser risings and descendings all the way over. A temporal work of art guides the spectator along a trail over the range. A spatial work of art takes him across in an aeroplane. The ups and downs of interest, the rising climaxes and the suspense are more intimately felt by the temporal spectator, but the spatial spectator has the compensation of tracing from his elevated view any of many paths he can see and of taking a different one in his imagination each time.

The interest structure of a work of excellent art is its last seal of perfection. For it demands in the artist a sense of the whole thing all the time, and it constantly requires him to sacrifice vivid, precious details to which he may become devoted and which he perhaps can never recover again. It means that inspiration in an artist is not enough for greatness. Or rather, it means

that the great artist must be so full of inspiration that he can reject half of his happy ideas and still have enough for the balanced justness of sustained vividness of quality. It means that excellent art is inspiration under restraint.

Chapter IX

ÆSTHETIC JUDGMENT

We have now made the circuit of the æsthetic field. We have not studied the details, but we have marked most of the prominent features. Though we have done this without any intention of making judgments of better or worse, nevertheless we have dropped frequently into the use of critical expressions. We have spoken of 'great beauty,' 'excellent art,' 'good taste.' In this concluding chapter, it remains for us to justify these expressions. As a matter of fact, they are not equivalent. They refer to distinct judgments. The first is the basic and primary æsthetic judgment. The other two, though founded on the first, have further references which render them complex, and, from the purely æsthetic point of view, somewhat oblique. For various reasons, however, the last two are the judgments in which we are most interested in æsthetic criticism. We shall consider the three separately.

In the introduction, we distinguished between

definitive and standard beauty. Definitive beauty is the term applied to any object that falls within the æsthetic field. Since our theory defines beauty as enhanced quality of texture, it follows that any texture of vivid quality is an object of beauty. There is obviously, for this definition, no sharp line between things beautiful and things not beautiful, since quality fades from textures by degrees. But at the extremes there is no question, and it is only with textures about which there is no question that we are greatly interested æsthetically. Moreover, the fact that beauty shades over into practical life and other predominantly relational attitudes simply shows that there is no problem of incompatibility between making a living and appreciating life, but that each attitude can suffuse the other if both relax from their extremes.

The primary æsthetic judgment, then, for our theory is, "This is a texture vivid in quality." The judgment is always positive. For if a texture is not vivid in quality, it simply falls outside the æsthetic field and is of no æsthetic concern. It may be practical, or scientific, or what you will, but it is not æsthetic, and therefore

æsthetically we cast no aspersions upon it. We merely withhold judgment. Consequently, according to our hypothesis, there is no ugliness.

But according to our hypothesis, there are degrees of beauty. To find the quantitative standards relevant to a definition of beauty, we learned in the introduction that we have only to see what properties of the definition are capable of quantification. These properties then are the standards for judgments of degree. Our definition of beauty, "enhanced quality of texture," has two such properties on the face of it. There are degrees of intensity of enhancement and degrees of extensity of texture. It then dawns upon us that our book has been divided squarely down the middle in the study of these two standards of beauty. For in the first four chapters we were concerned with the means of obtaining vividness of quality, and in the last four with the means of obtaining spread of quality. We were unwittingly guided through our exploration of the æsthetic field by these two standards of æsthetic excellence. The various means of producing novelty and conflict and emotion in the enhancement of quality, and the

various means of organization towards the attainment of spread of quality, are, accordingly, subsidiary instrumental æsthetic standards through their contribution to the gathering of great intensive or extensive quantity of quality. But the two ultimate standards of beauty are vividness and spread of quality.

There is possibly a third ultimate standard, which may be called depth. Textures, as we have seen, do not stop suddenly with sharp boundaries. It is true that vividness of quality is relatively insulative and focalizing, condensing outgoing relations into ingoing character. But the character of a texture is the very character of those relations felt and realized. Now, the strands of textures lead into environmental textures of different degrees of permanence and richness. The richest and the most permanent of these are those social interests of which we have spoken, and which we said are funded in qualitative textures and contribute their character and their organization to those textures. Individual textures participating in these social interests acquire a depth and a solidity of character which textures not participating in them

lack. They are richer, bigger textures. Now, the difficulty is that these enriching social interests are largely extrinsic to the appreciated texture. They are not literally, as are types, patterns, and designs, present in the spread of the qualitative texture appreciatively intuited. Yet they unquestionably add a measure of beauty to the textures which participate in them. Is this increment of quality which they contribute by participation, and not by actual full presence in the appreciated textures, to be regarded as a third standard of beauty or is it rather to be regarded as one phase of the standard of extensity? It does not make much difference how this quantity of depth is relegated, so long as it is recognized. For as to its importance there is no question. Without it, beauty may be glowing and spectacular, but, like flowers in a vase, lacks roots. The highest beauty is an individual texture (1) vivid in quality, and of great (2) spread and (3) depth. Great spread, of course, does not mean that the experience necessarily spreads over a lot of space or time, though it is likely to, but it does mean that it contains many strands.

This three-fold discrimination, then, is the basic æsthetic judgment. But it is a judgment that applies only to individual textures as they occur. It applies to a dream as well as to the perception of a statue, and it applies to each separate perception of a statue separately. For today I may be tired and irritable; or the statue may have been carried into a corner in a bad light, so that the texture of appreciation acquires little vividness. Such accidents are unfortunate. Nevertheless, they are facts, and, though the statue may have potentially the sublimity of heaven within it, the judgment of the æsthetic value of such moments of experience is low. They are not experiences of great beauty.

It makes sense, however, to say that we *ought* not to judge a statue by such experiences as these. Note that we do not make this normative statement about a dream. Whatever our judgment of the quality of a dream, whether weak or vivid, that judgment stands, and nobody would think of telling us that we *ought* to have found the dream either more or less vivid, or more or less organized than we did. Yet of the statue this is just what people are likely to say, and

we ourselves are likely to say it to ourselves. I admit to myself that I *ought* to have felt the beauty of the statue more intensely and more deeply, but unfortunately I was tired and moreover it was so dark I could hardly see it.

This *ought* shows a reference to something more involved in the judgment of a statue than the judgment of one experience of it, or even of the sum of all experiences of it. There is what may be called a *normal* æsthetic perception of the statue, and perceptions with a discrepancy from the normal one *ought* not to be considered representative æsthetic judgments. We begin to see that the applicability of this *ought* has something to do with a factor of continuity which the statue has, and the dream has not. There is a system of impersonal strands, which we call the physical statue. These have a continuity, and a capacity of interweaving with systems of personal strands in the generation of the complex vivid textures. These personal-impersonal vivid textures may be called the æsthetic statue. Now, the relation between the physical statue and the æsthetic statue is somewhat involved.

The physical statue is generally created by a

man for the purpose of generating and preserving an æsthetic statue. But whatever the artist's motivation, a physical work of art, in so far as it is preserved for its æsthetic values, is cherished solely for its capacity for generating an æsthetic work of art. From the æsthetic point of view (for, of course, we are not interested here in the historical, or anthropological, or political, or economic, or commercial values of a work of art) it is the æsthetic statue that governs the value of the physical statue. In other words, the only æsthetic value of the physical statue is its preservation and control over the æsthetic values of the æsthetic statue. The thing of beauty is solely the æsthetic statue, but what makes it a joy forever is, we must not forget, the physical statue.

To obtain the thing of beauty from the physical statue, certain conditions both of an impersonal and of a personal nature must be fulfilled. It is these conditions which impose the *ought* on the judgment of a work of art. The conditions differ for every type of art. For a statue, the impersonal conditions are that it should be seen in a good light, and in a proper

environment. By proper environment is meant at the very least a good chance to get a look at it without being jostled, or having people constantly pass between you and it, or having somebody talking into your ear. At the most, it means careful consideration of height, of background, of distance and perspective, and of all neighboring objects; and if the statue was made for a particular building or place, seeing it, if possible, in place.

As to the personal conditions, these consist in a receptive mood and adequate experience. By adequate experience is meant good taste, about which we shall speak presently. But by receptive mood is meant a general readiness of the system of personal strands to splice themselves onto the system of impersonal strands and generate the total organized texture to the full capacity of the spectator. At the very least, it means that the spectator should not be overtired, or in a captious mood, or full of practical business. At the most, it means high susceptibility, keenness of discrimination, and a readiness for fusion and even seizure, as Dewey calls it.

The addition of the personal strands to the im-

personal strands in the production of the full æsthetic work of art introduces a concept of great importance in æsthetic judgment, namely, relevancy. The personal strands should be relevant to the impersonal strands and relevant to each other. A name (made famous by Coleridge) that has been given to relevant construction is imagination. For the imagination in this sense is nothing other than the prolongation of the impersonal strands into the personal system and the enrichment produced by the personal strands in the generation of the total æsthetic work of art. Imagination, in short, is the personal contribution to the æsthetic work of art. Without the imagination, all that is left is the physical work of art, which is describable only in the analytical relational terms of physics. For what may be the qualitative nature of a statue apart from the human contribution in perceptions we can only speculate. Of what pertains to the physical statue we are cognizant only of its relational structure, and we are not even exactly sure what that means. Yet this relational structure is all we know of the continuity, which controls successive æsthetic experiences, and which

renders possible an objective judgment on the work of art.

The way imagination operates is something like this: The physical work of art presents certain relations to be filled out by personal strands. In a statue these physical relations are comparatively easy to describe. They are the measurable sizes, shapes, proportions, and positions of its material, and so forth. When this system of impersonal relations encounters a system of personal relations (such as you or me) there occurs what we call an act of perception. In accordance with our powers of discrimination we bring into the texture of our perception the relevant qualities of the schemes in which the physical relations participate. As a result, the sizes and shapes and positions take on pattern and design. We then say that we have a sensuous perception of the statue.

But the construction of the æsthetic statue does not stop here. There are funded interests in which the statue participates. The perception is perhaps that of a man in a graceful posture endowed with elegance and refinement. The man, the grace, the posture, the refinement, are

all names for funded interests at various levels, in which the statue participates. The perception is enriched and deepened by these interests into an apperception.

But even here the construction does not stop. We are told that the statue is of Hermes. Perhaps by symbolism in the statue we knew that it was of Hermes without being told. Through this symbolism, portions of the history of Greece enter the æsthetic texture together with the Homeric legends, and the functions of the god, Hermes, in Greek mythology—Hermes, the youth, the messenger, the patron of skill, and cunning, and eloquence, and athletic prowess, the son of Zeus and Maia. The apperception spreads into image and idea.

Meanwhile, during all this imaginative construction, intrusive novelties, dramatic conflicts, and emotions boil up and flow and water and saturate the texture with vitality.

In this manner, an æsthetic work of art is created out of a physical work of art. And the objective thing here is not primarily the physical work, which as a physical continuity we can know only as a thin system of schematic rela-

tions. The primary objective thing is this imaginatively constructed work. It is this last, and this last only, that we judge æsthetically and call excellent, if we can.

The relative importance of the three stages of imaginative construction, which I have outlined, varies greatly in different types of art. For it must not be assumed that the perceptive construction is always the most important or objective, the apperceptive less so, and the ideal a sort of arbitrary and unnecessary accretion. In the Hermes of Praxiteles, which I have been keeping in mind (and it makes little difference in our judgment whether it was Praxiteles himself who made the statue or some later equally sophisticated sculptor) the apperception seems to me rather more important than the perception, and the idea only a sort of emotional guide. On the other hand, the sculptures from the pediments of the Temple of Zeus, also still at Olympia, seem to me to weight the perception and the idea about equally and to push the apperception into a relatively minor rôle. It is the emphasis on the perceptive qualities that leads us to call the pediment sculptures sculpturesque in contrast

with the Hermes. They emphasize the rock and the hewing of it, where the Hermes seems to shrink from its material and to conceal by its very technical facility the manner of its making; they emphasize solid volumes, where the Hermes emphasizes lines and folds, and surface textures of flesh and hair and drapery; they emphasize weight and the physical strain of forces, where the Hermes emphasizes the body of a man. The Hermes, of course, is excellent in pattern and design, but it seems to use these as embellishments to set off a godlike human form. And the pediment sculptures certainly represent heroic men and women and centaurs, but not so much for their humanity and animality as for the forces that pass through them, physical and mythological.

Many of us in this generation are especially interested in the perceptive qualities of sculpture and tend to prefer the pediment sculptures at Olympia to the Hermes. But we need only recall the judgments of a generation just past to wonder if we are not subject to a temporary bias. And I am not sure but that both judgments underestimate the importance of the ideal qualities

(so glibly today called 'literary') in the pediment sculptures.

These comparisons, I think, help to show what æsthetic objectivity means. There exist textures which we call permanent æsthetic objects and to which we give names such as—the Hermes of Praxiteles or the pediment sculptures at Olympia. We do not mean by these names fragments of stone. We mean the imaginative constructions. These constructions are systems that we gradually work ourselves into from many different views and through much experience. Their nature sometimes seems inexhaustible. But the basis of their objectivity is relevancy founded on a group of physical relations.

The test of relevancy is not whatever is suggested by the physical work of art. A physical work of art can suggest all sorts of irrelevant things. The sculptures at Olympia will always suggest to me rain and mumps. Those are persistent and vivid associations, for it was raining when I was at Olympia and I had the mumps there. Even an artist's intentions are not a certain test. An artist rarely knows his full intentions, and is often as much surprised by his crea-

tions as any spectator. The test is whether a strand, be it a perception, an apperception, or an idea, ties back into the texture. If it is at loose ends, it does not belong to the work of art, but if it weaves back into the total texture or is called for and demanded by other parts of the texture, then it is relevant and of the æsthetic object. The more highly organized a texture, the more its strands mutually demand one another, and the greater its objectivity.

It does not follow, however, that an æsthetic work of art is exactly similar in the experience of all competent spectators. On the face of it, the notion of exact similarity is a sort of nonsense to a contextualist. Every experience is qualitatively unique, so that as a matter of course the æsthetic experiences of two different spectators would be different. All that can be meant by similarity is that the strands of two textures lead into common schemes. To a large extent, this, as we have seen, is the mode of organization in a work of art, and to this extent the æsthetic experiences of two competent spectators will be similar. But æsthetic objectivity can be obtained without similarity in even this sense.

ÆSTHETIC QUALITY

Probably the most familiar ground of objectivity with dissimilarity is that of different types of imagery. People have different modes of imagery. A word, say "swallows," for some people calls up a visual image of the birds (if it happens to suggest a physiological act, that in itself is a whole lesson in context and relevancy), for others it calls up an auditory image, for still others a line of flight. Some people are incapable of producing some of these kinds of imagery. Obviously, the images of a poem will differ greatly for different people according to their image habits, and yet poems rely greatly on images. In spite of these differences, there may be no diminution of objectivity in the specific realization of the line:

And gathering swallows twitter in the skies.
(Keats, "To Autumn")

The visual image ties in through the reference to the spatial location 'in the skies,' the auditory image ties in through 'twitter,' and the line of flight through 'gathering.' Any one of these images, or all of them, is relevant—and in all manner of proportions.

236

Moreover, there is no diminution of objectivity even when different images are simultaneously incompatible. The line quoted calls for still clearer realization than I have hinted. To obtain this clarity we have to delve into our personal experiences and these of necessity differ from person to person. If the clearer developed image I gather goes back to an evening in a New England town and a road through an avenue of elms and a white farm house and a large white barn and the dampness of dew in the air and stubbled autumn fields and the swallows circling over the trees and the barn, I do not expect any other man to find his realization of the line from the relevant images of this specific experience. Of course, as I read the line, I drop out the New England town, the elms, and the white farmhouse and barn, since, quite apart from the atmosphere of Old England that saturates the poem and the poet, these are specifically excluded by an earlier line,

With fruit the vines that round the thatch-eaves run.

The New England scenery retires and (except

for the motive of this analysis) is excluded or disappears, while the other details of that autumn evening and its gathering swallows come forward. This personal image is relevant, and is part of the structure of the poem in the context of my mind. The poem calls for just such intimate fulfilment, and of necessity this must be different for all readers whose personal memories of some 'soft-dying day' in autumn are different. A person with no such memories cannot fully realize or objectify the poem. These are our personal interpretations intended and expected to be different from reader to reader, like the personal interpretations of a composer by performers with adequate experience.

Sometimes, as in a performer's interpretation of music or a sensitive reader's or critic's interpretation of poetry, some of these personal fulfilments can be communicated. We may then accept several interpretations as relevant. They are alternative ways of completing the artist's creation. But sometimes these fulfilments have to be almost entirely private. Whether public or private, they are just as objective, provided they are relevant fulfilments and are the pro-

longations of systems of strands having their roots in a physical work of art.

Nevertheless, over all this there lies an assumption of normality of some sort. The assumption consists in an assurance of a capacity for imaginative construction in the manner described, and according to the three stages previously described. A man ought to have the perceptive capacities to construct the relevant sensuous perception. A blind man cannot perceive visual relations. A color-blind man misses the hues. A man without a rhythmic sense misses balance and the swing of line and the subtleties of repetition. Secondly, a man ought to have the relevant apperceptive capacities. He ought to have the normal strength and direction of human drives to feel the relevant instincts and habits, and he ought to have the cultural background to participate in social structures so as to fund the relevant interests. Lastly, he ought to have the intelligence and fancy to catch the relevant ideas and images and have the invention to prolong the imaginative construction to the fullness of vivid personal realization.

The normality supposed here is not that of an average man. The perceptions are supposed to be more discriminating, the apperceptions deeper, and the idea and image construction surer and swifter. The normality is that of the average man raised to the fullness of his capacities. What is implicitly excluded is physical and physiological incapacities of perception, and psychological incapacities for relevant imaginative construction.

The importance of the assumption of normality springs from the fact that it lifts æsthetic works of art out of the category of dreams, and converts them into social objects, and endows them with an authority as extensive as the society in which this normality endures. Of a dream, as we have remarked, no one can say that we ought to have appreciated it more or less than we did. But of a work of art, men do say this. And what they mean is that, if we are normal men, as they trust we are, and with normal capacities of development, then if we do not appreciate the Praxitelean Hermes, or do not appreciate the Olympian pediment sculptures, we are missing something rich and real,

and the presumption is that we are lacking in an adequate development of some side of our appreciative natures. It follows that æsthetic works of art can be discussed in great detail, and that as definite decisions can be reached about them as about anything in the world except the most precise scientific descriptions which have a superior definiteness only because scientists are willing to eliminate anything whatever for the sake of their ideal of invariancy. There is absolutely no question of a high degree of relevant imaginative organization in the Hermes, and it is not difficult to describe in great detail what is there organized, and a normal man with considerable æsthetic experience in sculpture cannot help responding to the vivid qualities that emerge from it—provided he is not approaching it unsympathetically. And if he is approaching it unsympathetically, that attitude also can be analyzed and described. Two normal men of today who are receptive to the Hermes and permit it to develop itself in their imaginations will not only understand each other as the æsthetic work builds up, but they will be able to assist each other in the building, and

they will discover its blemishes, which are as definite and open to judgment as the weaknesses of some particular form of government. It is precisely through discussion and the mutual critical assistance of normal men of long æsthetic experience in particular forms of art, that the classics have been separated from other works of art and set in places of honor. These, the classics, are physical works of art which are guaranteed, so to speak, by the judgment of many competent men to be capable of imaginative construction into individual textures of great depth and spread and vividness of quality.

There is nothing eternal about such judgments. The classics of one age are not exactly the classics of another. Works are 'discovered' and become classics in one age which were not so in another, or become more greatly admired in one age than in another. For since every man must belong to an age, and since the cultural and possibly even the physical structures of every age differ in some degree from every other, it is inevitable that the normality of man, and his capacities of organization and realization, should differ from age to age. So, every age does need

its own critics to judge and show where are the richest qualitative textures for that age. Yet there are some works of art so rich and partaking so largely of the least changeable structures that we can almost risk the prediction that they will never die while men live. Are these the greatest works of art because of their survival? No, not because of their survival. But since artists of the highest creative power are rare, the greatest works of art according to the judgment of any epoch are likely to be mostly those that have survived through other epochs.

And now what of good taste? The substance of all that needs to be said of it has been said already. When we judge that a man has good taste, we judge that he has the full capacity of imaginative construction relevant to the work of art or the type of art under consideration. We judge that he is normal in the superlative sense of normality, which we recently defined. Such normality for any particular type of art is likely to be most commonly found among the artists creating in that specific field of art. But there is a danger in trusting implicitly the judgments of artists. Many artists with marked

creative ability lack judgment. They can create but not recreate. But the greater danger is the arrogation by an artist, who excels in a particular field, of a right to pass judgment over a much wider field. Artists are safer critics in what they admire than in what they dismiss. When T. S. Eliot admires Donne, we can trust his discriminations and learn to follow his leading. But when he damns Shelley, we do better to follow some other critic's leading.

No man has good taste in all things. It is one of the virtues of an able critic to be aware of the limitations of his judgment, and to try to guide people only in those fields of art where his experience is adequate. The determination of the limits of a man's judgment is not easy to make. A good judge of painting rarely pretends to be a good judge of music. But many good judges of Renaissance painting recently pretended to be good judges of modern painting and condemned it *in toto*.

To judge a work bad, a critic must be big enough to see all around it and all through it. He imaginatively reconstructs it and sees that it is worthless and sees that he sees all around

the man that made it. Generally the worthlessness consists in a total lack of vitality. An imitative, academic work is very easy to spot if a man has enough experience in the works of the type imitated. But sometimes a work has genuine elements of vitality, and what the critic condemns is an obvious diversion of the relevant construction of the work to some cheap end. The judgment is a regret that something which might have developed into a rich qualitative texture was permitted to be turned aside into something thin and weak. A moral note even enters into the judgment, for though dullness may be excused on grounds of simple lack of capacity, insincerity is never excusable.

It is such judgments of worthlessness ascribed to intended works of art that are generally called judgments of ugliness. But a work of art is never strictly speaking ugly. It is worthless, or worth so much less than it might have been, that it makes us morally sick to think about it. If we wish to call works that make us feel this way ugly, I suppose there is no great harm in it, but the point is that there is no logical justification for it, since there are no negative

æsthetic values. A texture is as beautiful as its spread and depth and vividness of quality, and, where such quality is lacking, the texture simply passes outside the æsthetic field. For an æsthetic work of art is simply an intricate individual texture of enhanced quality.

Taste, however, can definitely be bad. It is bad taste to say something is beautiful when it is dull and empty, or to say something is very beautiful when it lacks depth and spread and intensity, or to declare that the beauty of a work rich in imagination is on a level with something superficial, or to be fooled by insincerity. In short, it is bad taste to make errors in æsthetic judgment. The evil of bad taste, however, is not the trivial matter of making mistakes, but what develops from the consequences of habitually doing so. It has been our main point from the beginning that quality is the very essence of life and nature, so that a man who cannot find depth of quality when it is within his reach is a man who does not know what life or nature is. He may be as erudite or efficient as you please, but he will not know what his erudition

or efficiency is about. His effectiveness will depend upon the insights of other men who did once know. For in the end, nothing is valuable but the quality of something.

INDEX

INDEX

INDEX

INDEX

intrinsic-extrinsic type, 116
intrinsic organization, 168; function of, 169
intrinsic structure of art, 169 f.
intrinsic type, 116
intrusive novelty, 65, 70, 71, 72, 83
intuited aspect, 46
intuition, 22, 25, 26, 29, 30, 40, 46; pure, 27

James, Henry, 104, 153; quoted, 103, 107, 151 f.; theory of the emotions, 90, 93

Keats' "Endymion," 68; "Ode to a Nightingale," 113
keys, arrangement of, 177; relationships, 133
knowledge and analysis, 29

limitations, 169
lines, 68, 137 f.
Lubbock, 101

Macbeth, analysis of, 78
McDougall, William, 92
Mann, Thomas, 164
Mass, 141
Matisse, 68, 215
mechanistic point of view, the, 7
Meissonier, 164
melody, 127
meter, 180
Michelangelo statue, 190
Milton, John, 14, 118
Molière, 14
Monet, 65
monotony, 55, 190 f., 204 f., 210
multifies, 174

music, 94, 99, 134, 145, 156, 176, 179, 207, 211; among the arts, 199 f.; art of suspense, 86
musical forms, 160
musical scale, 207
mystic experience, 105
mythology, 30

narrative literature, 162
natural interest, 199
natural type, a, 162
non-axial compositions, 188
normal æsthetic perception, 226
normality, assumption of, 239 f.
novel, 44, 99, 134
novelty, 54-70

object, the individual, 38
objectivity, 5, 10, 198, 237; of disintegration, 11; of integration, 11
opposite aspects, 22
organization, 53, 109, 150, 156, 168; by attention, 183; modes of, 172; of the piece, 174; sources of, 116; total, 45
original intuition, 23
ought, in judgment, 225 f.

painting, 88, 101, 134, 162, 215
Paradise Lost, 118
patriotism, 123
pattern, 178, 194; of action, 93, 95, 117; an intrinsic mode of organization, 168-193; use of word, 169
perception, 24, 38, 163; balanced, 28; of Shono print, 23; texture of our, 230
perceptive construction, 232

INDEX

INDEX

ugliness, the term, 16
unbalanced compositions, 187 f.
underlying physical conditions,
33
uniqueness, 61, 63
unit patterns, 179
unity, 178; advantages of, 176;
strict sense of, 173 f.
unrestricted repetitive rhythms,
191 f.

Vanity Fair, 120

variety, 195; three principles of,
202 f.; ways of achieving, 203
verse, unit patterns in, 180 f.
vitality, elements of, 245
vividness, principle of, 213; of
quality, 222

width, 135
Wilde, Oscar, 65
words, 66 f.
Wordsworth, 55, 164